Seasons of
MAINE

Seasons of MAINE

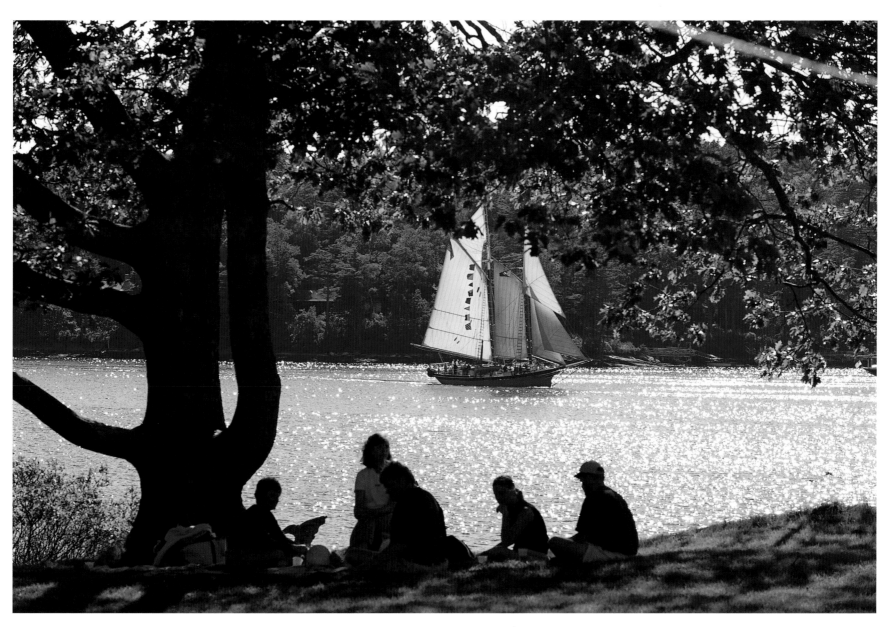

William Hubbell
captions by Jean Hubbell

Down East Books, Camden, Maine

To our parents,
Brad and Dot Hubbell
and
Randy and June Miller
for opening up the world to us.

Design by Lindy Gifford
Printed in China.

5 4 3 2 1

Down East Books
P. O. Box 679
Camden, Maine 04853
book orders: (800) 766-1670

ISBN 0-89272-488-9
Library of Congress Control Number: 2001087982

Cover photographs from upper left:
Katahdin from the Golden Ridge Road, Sherman Mills.
West Quoddy Head Light, Lubec.
Freshly painted lobster buoys, Cushing.
Wild-blueberry barrens, Whitneyville.

Title page photograph:
Picnickers enjoy Cabbage Island as a windjammer sails
across Linekin Bay in Boothbay Harbor.

In many areas of the United States, you can cross a state line and be unaware of any change. Not so when entering Maine. Sometimes you pass high over a swift-flowing river; sometimes you snake through a low-lying cedar swamp. Either way, a few miles after having passed the border, a subtle awareness sneaks in. The woods seem deeper, the sky higher, the air fresher, the spaces wider, the distances longer. Maine is an expansive place—for the spirit, for the body, for the soul.

Consider the elements that make up Maine—the rocky shores and pointed firs, the lobster and moose, the clear, blue lakes and tall mountains, the brook trout and landlocked salmon, the forests and potato fields, the windjammers and lighthouses, the black flies and chickadees. All these exist elsewhere. Not one is exclusive to Maine. What is special about the Pine Tree State is the way these elements, and myriad others, combine to make the whole so vastly greater than the sum of its parts.

Aside from the natural beauty of Maine, there are its people: dry-witted and taciturn, cautious but friendly, deeply loyal to family and community, independent and free-thinking, self-reliant and wise, tempered by hardships but for the most part happy to live where they do.

When this environment and this population are combined, the resulting mix—the state of Maine—is, without question, unique.

The challenge that my wife, Jeannie, and I faced in this book was to capture this essence through all four seasons in all of Maine's diverse regions—from Fryeburg to Lubec, from Kittery to Fort Kent. Fourteen months, thirty-two thousand miles and six hundred and forty rolls of film later, our contract said time was up. Of course, we didn't work steadily during this period. Rather, we waited for the right weather and made a number of forays across all sixteen counties, each trip calculated to take advantage of the scenes and events in the specific areas we wished to cover.

When working on an open-ended project like

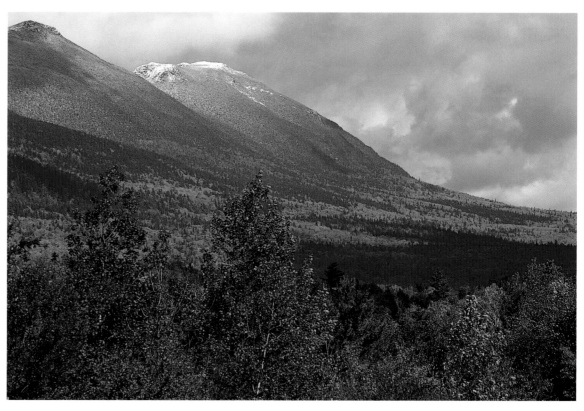

this one, where I have the luxury to decide what to photograph, my aim is to work with the minimum of photographic gear. My cameras were a Nikon F5 and a F100, one mounted with a 28mm–70mm zoom and the other with an 80mm-–200mm zoom. I also carried 20mm and 28mm PC (perspective control) lenses, filters (graduated and polarizing), film (Fuji Provia F100), a handheld light meter, and a tripod. Helpful backup items included a compass, tide tables, miniature tape recorder, marking pens, batteries, a flashlight, "raincoats" to keep the cameras dry in flurries or downpours—and a lightweight parka for me. In my car kit, along with blaze orange outerwear, snowshoes, rain gear, travel food, wading boots, dry socks, and a six-foot stepladder, I carried a small strobe and a 300mm lens with tele-extenders.

As a photographer, I approach the production of a book like this as I would a treasure hunt, where the image is the gold I seek. Calling on intuition, experience, thorough research and

Late-fall snow dusts the peaks of the Bigelow Range in Stratton.

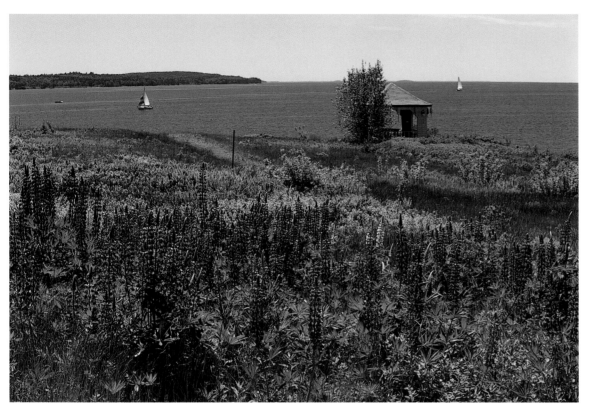

Spring-flowering lupines grace the shores of Penobscot Bay in Stockton Springs.

above all, patience, I am generally rewarded. (It also helps to have a strong back and legs and an enthusiastic companion.) I always seek the special soft, low light of dawn and dusk. That inevitably makes for many long days. Often it took four or five visits to a location before the quality of the light met my expectations.

Wayne Gretsky, the great hockey player, said "You miss 100 percent of the shots you never take." How true! With the whole DeLorme Maine Atlas as my treasure map, the task was simply to get out there and shoot. No one else was going to do it for me. Since I was dealing with a landmass as large as the five other New England states combined, there was plenty of gold to search for.

In the course of our mission, Jeannie and I developed a deep appreciation for—and a debt of special thanks to—the many Mainers who helped us find our way:

Heidi Lackey for her magnificent work producing thousands of slide labels; book editor Chris Cornell and book designer Lindy Gifford for their wise and enthusiastic guidance in pulling 14 months of work into these 112 pages; Audrey and Tib Thibodeau for their guided tour of "The County"; Arnie Nepture for his wisdom regarding Maine's Native Americans; Meredith Wnek and Bob Russell for their original instigation of the project; Dave Lackey for his encyclopedic knowledge of Maine and its people; and Bob Stewart for his information on the wild blueberry industry.

And then there were groups: the staff of Portland Color for their excellent service and reliable film processing; Mike Whipple, Sarah Kulis, and the Marston family, each for being at the right place at the right time; Bud and Robin Singer, Lee and Holly Thibodeau, Dick and Ginny Kurtz, and Tom and Martha Calderwood for making the waters of Casco and Penobscot Bays accessible; the dozens of willing informants from chambers of commerce, government agencies, museums, businesses, and organizations across the state who fielded our questions and guided our efforts.

Finally, I want to thank Jeannie, whose support and enthusiasm for this project was equaled only by my own. Together we had a joyous time making all the diverse elements work, and only on a few occasions did she give in to a fit of pique "Oh, no! You don't want to go up *that* cliff (or roof or mountain or mast or tree), do you?"

Some years ago, a newspaper editor summed up Maine this way: "Anybody who ever has been to Maine loves it, and those who haven't been here love it too. The common perception of Maine across the country is as a state of independence, quality of life, and great natural beauty." We couldn't agree more!

William Hubbell
Cumberland Foreside, Maine

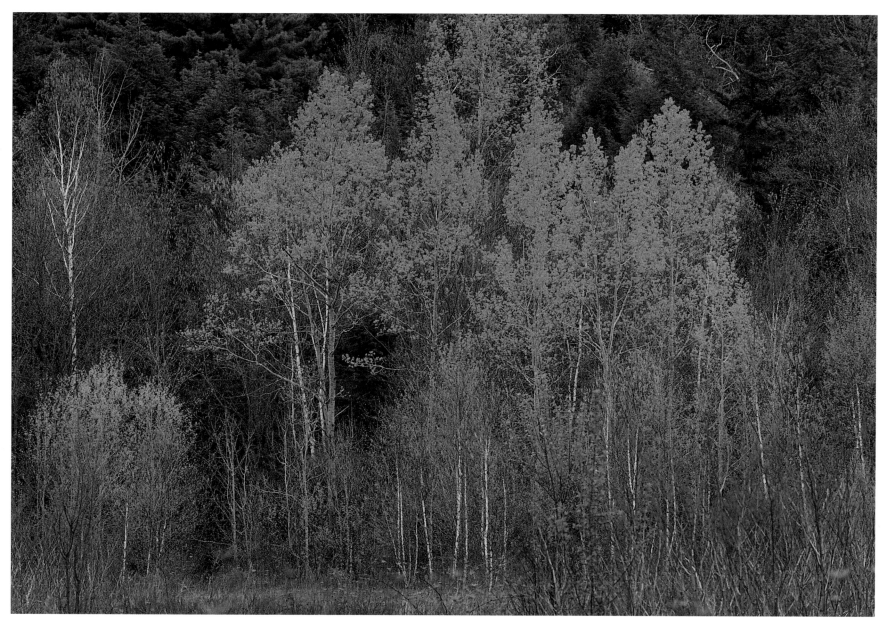

Fresh, new leaves sprout on poplars taking over
an abandoned field along Route 1 in Falmouth.

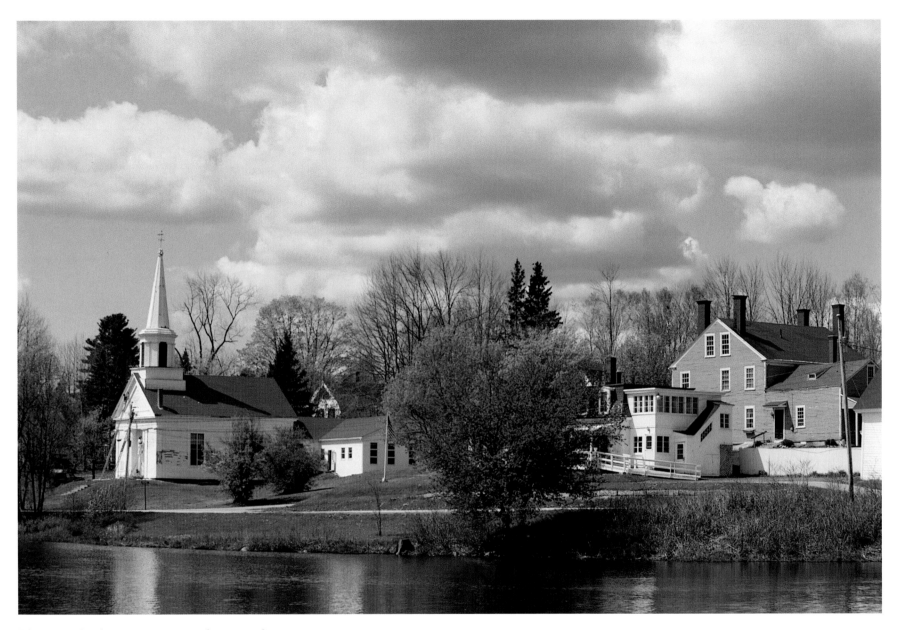

It's spring freshening-up time in the town of
Orland as the United Methodist Church gets a
new coat of paint. Located on a side road off busy
Route 1, east of Bucksport, Orland retains much
of the purity that characterizes 18th- and 19th-
century New England towns.

Winters can be long and relatively colorless in Maine. So when spring arrives and rising temperatures allow, greenhouses and nurseries such as this one in Yarmouth explode in a riot of color, gladdening every Mainer's heart.

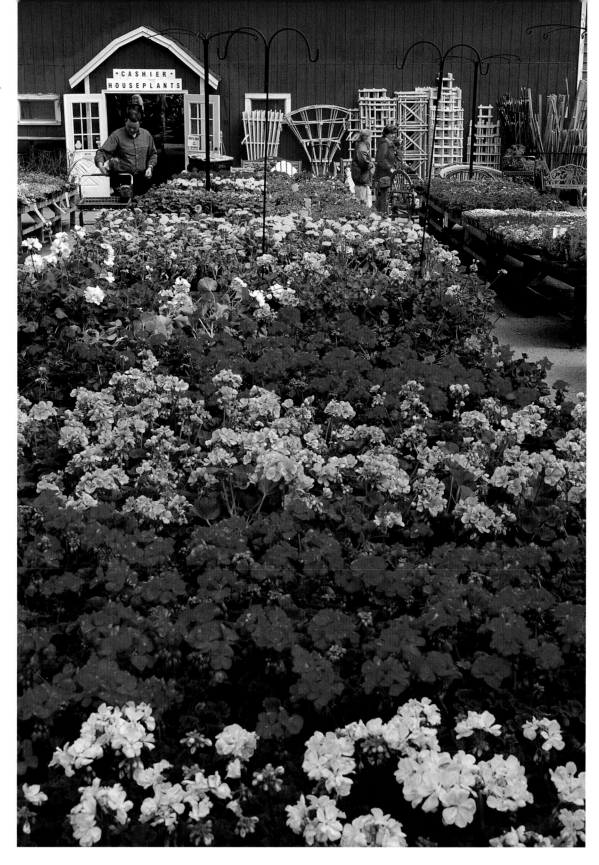

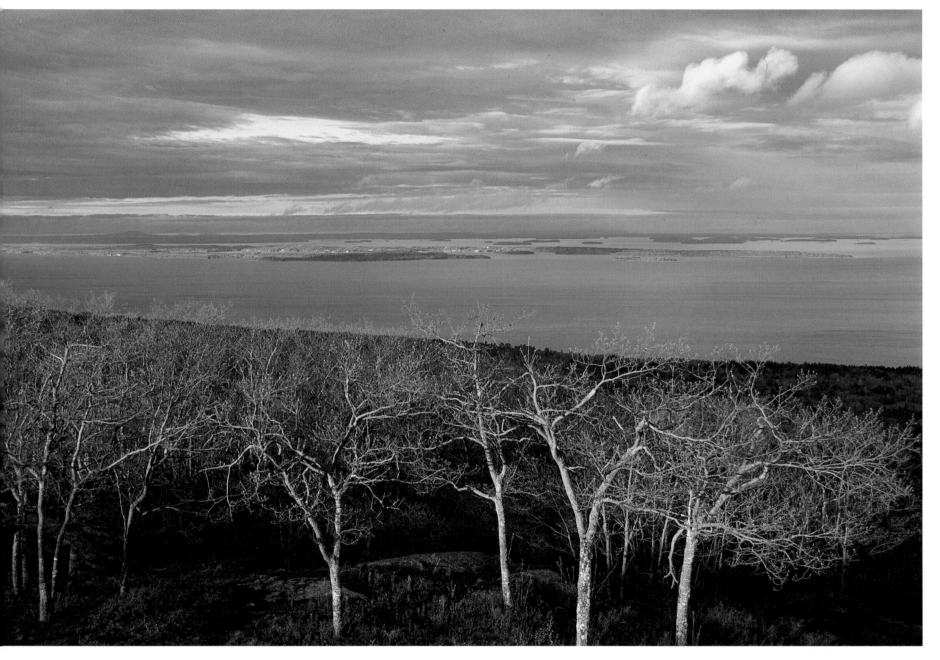

In a moment of serenity on Penobscot Bay, Islesboro's low profile catches the glimmer of an early-spring sunset taking place to the west. The viewpoint is the summit of Mount Battie, which rises some six hundred feet above the sailing and tourist mecca of Camden. An automobile road to the top makes for some of the most easily attained and beautiful views in midcoast Maine.

Town meetings, like this one in North Yarmouth, are held yearly, generally in the spring. The "home rule" form of local government in the Pine Tree State is an example of democracy at its idealistic best. Town taxes, zoning, roads, education—anything that requires spending the hard-earned dollar—make their way onto the town warrant for discussion, and there is usually plenty.

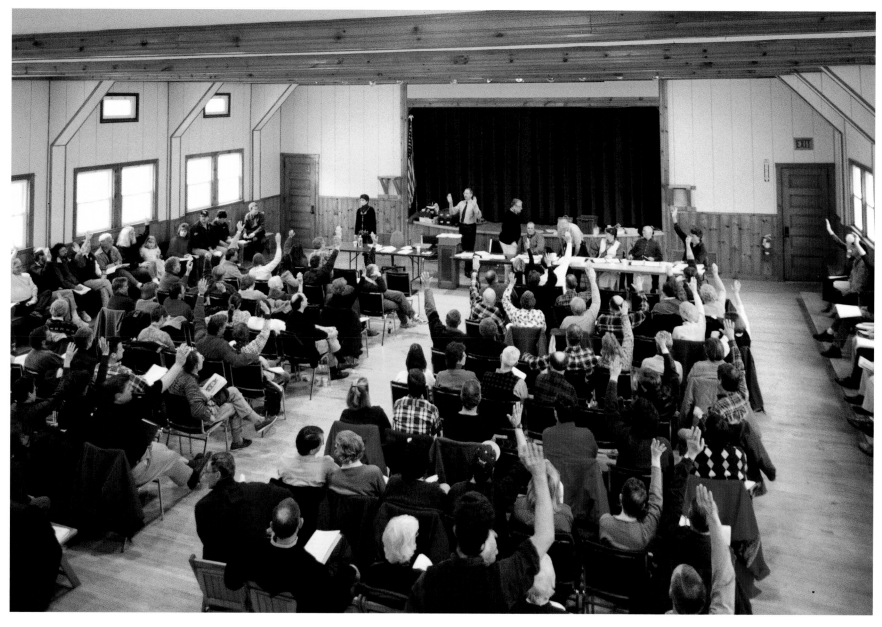

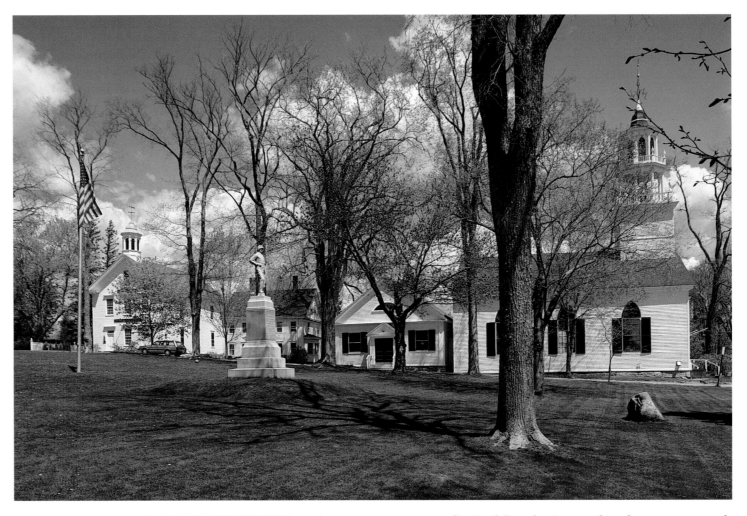

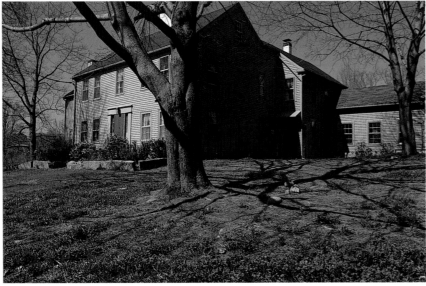

Spring foliage begins to soften the trees surrounding the village green in Castine. Home of the acclaimed Maine Maritime Academy, the town is located at the mouth of the Bagaduce River on Penobscot Bay's eastern shore. Its streets are lined with beautiful Colonial homes nestled under arching elm trees, befitting a town that, at one time or another, was controlled by the Dutch, British, and French.

Built in 1790, this center-chimney Colonial in Yarmouth is typical of the many antique homes that have been lovingly restored and maintained in Maine's rural towns and villages.

Reputed to be the first spot in the continental United States to greet the rising sun, Cadillac Mountain in Acadia National Park rises 1,530 feet above the ocean and is the highest point on the eastern seaboard. The summit is easily reached by car and offers views to all points of the compass.

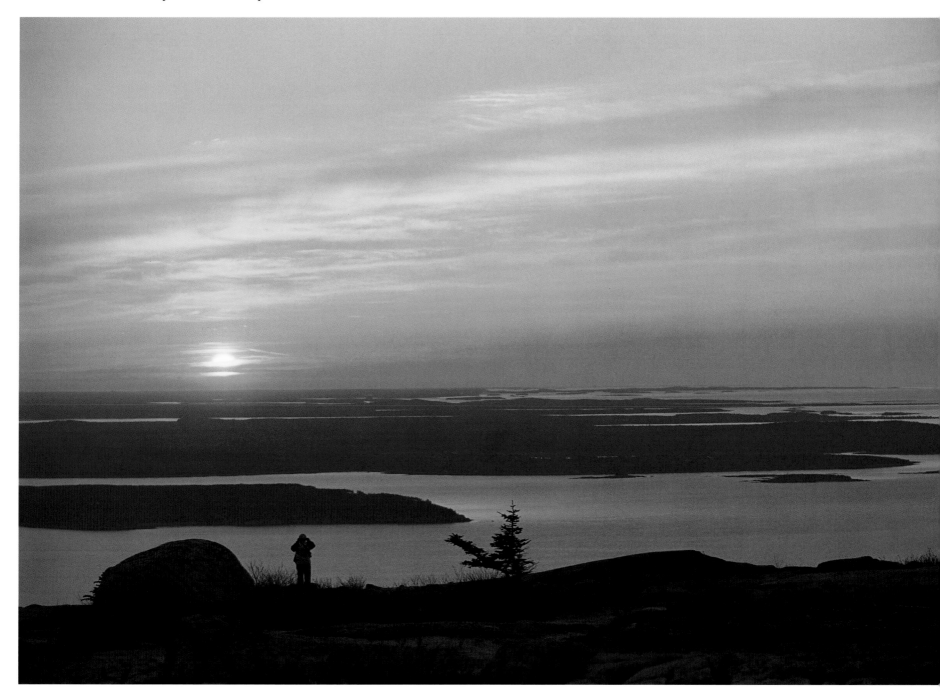

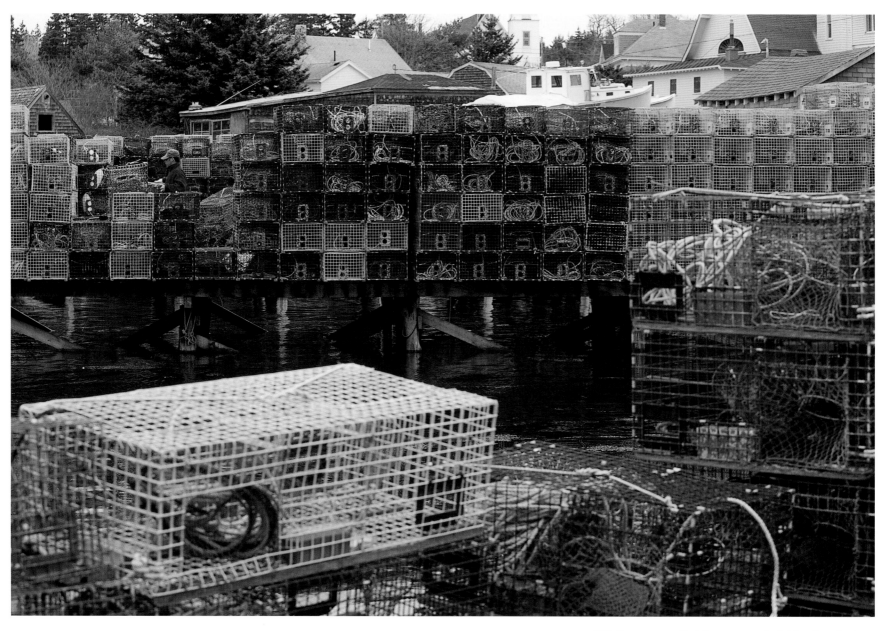

While not an official state symbol like the chick-
adee, moose, and white pine, the lobster ought to
be, for these armor-plated crustaceans are prac-
tically synonymous with Maine. Catching them
is not an easy process, requiring an extensive
investment in a boat, traps, line, buoys, and bait.
In the winter, lobsters retire to deeper water, and
most lobstermen pull their gear for the season.
Here, on a pier in Port Clyde, a lobsterman pre-
pares his traps for a new summer of fishing.

All lobster buoys have a color combination and number unique to the license holder. Traps may be set individually or in strings of five or more.

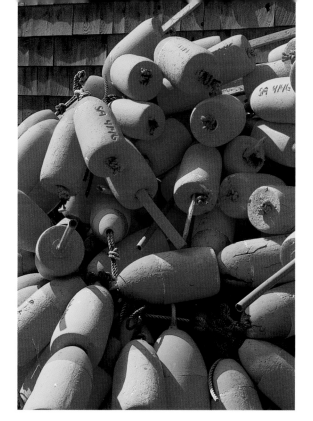

Almost eight thousand Mainers, fishing an average of 460 traps each, make at least a substantial portion of their annual income from lobstering. The industry is strictly regulated by the state, which—among other things—limits the size of the lobsters that can be taken, the number of traps each individual can fish, and the number of licenses issued.

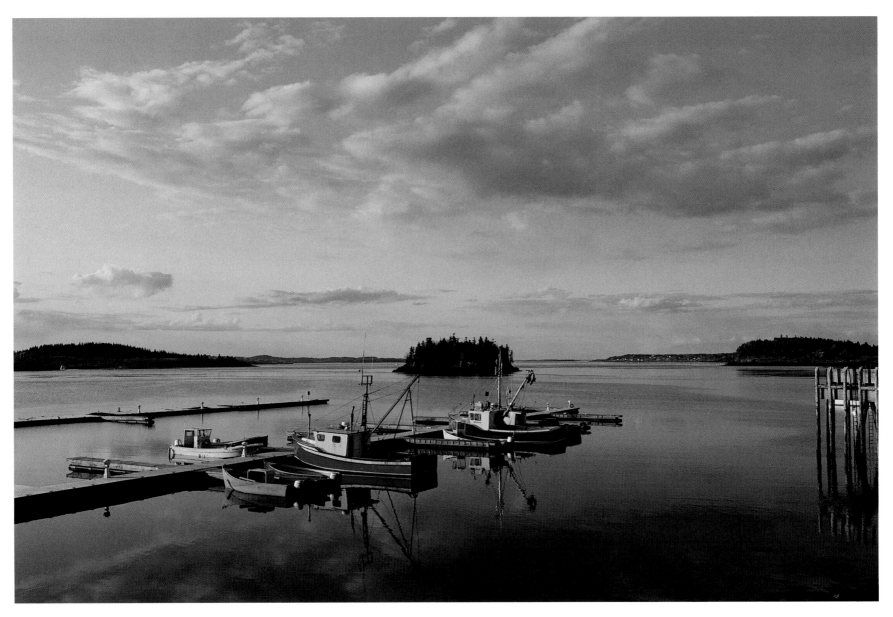

One can't go farther east in the United States than Lubec, located at the head of Cobscook Bay. The town sits across the water from Canada's Campobello Island, once a summer home of President Franklin D. Roosevelt and now an international park. A fishing community since the late 18th century, Lubec has seen tough times in recent years because of the decline of the sardine industry—from twenty canneries in the early 1900's to one today. Lubec is rebounding, however, with the growth of salmon aquaculture.

The appearance of fiddleheads along the banks of Maine streams signals the true arrival of spring. From the state's earliest inhabitants to its modern residents, Mainers have appreciated these unfurled ostrich-fern fronds as the first fresh, local greens after a long winter.

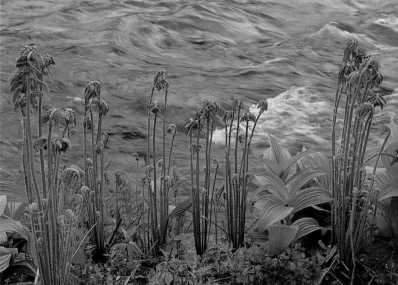

The best locations in which to harvest fiddleheads are secrets passed down from generation to generation. With a taste a bit like asparagus, these greens are delicious either steamed or sautéed with butter and lemon juice.

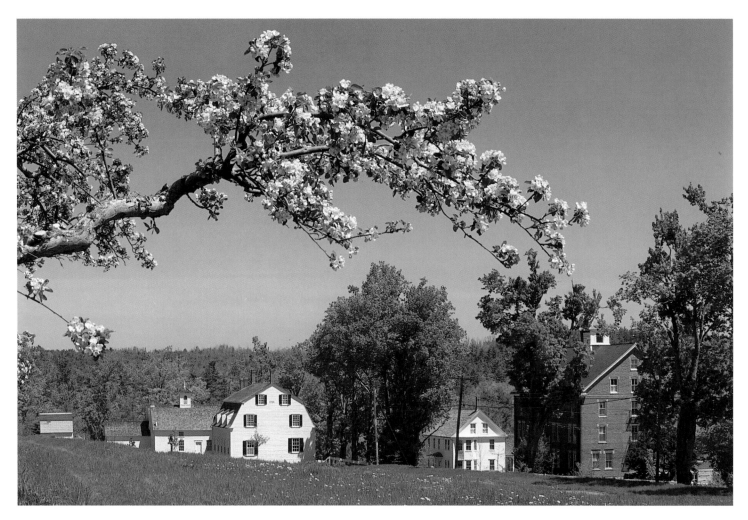

Tucked against the eastern crest of a hillside in New Gloucester is the Sabbathday Lake Shaker Village. Founded in 1783, this commune was once one of eighteen major communities east of the Mississippi espousing the same optimistic religious belief: "hands to work and hearts to God." Today Sabbathday is the last remaining Shaker settlement with active members dedicated to living a simple, monastic Protestant life.

Every spring, neighbors and friends of the Shakers gather on a weekend to freshen up the commune's buildings, where worship services are held every Sunday and instruction in such crafts as raising herbs and building furniture is given during the summer.

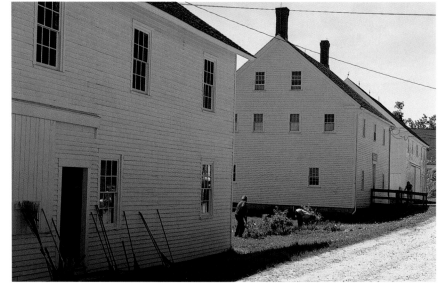

Aquaculture is a major, multimillion-dollar industry in down east Maine. Here at the mouth of Machias Bay, where the first naval battle of the American Revolution was fought in June 1775, pens measuring thirty feet in diameter by thirty feet deep hold Atlantic salmon that grow to a market size of some twelve pounds in two or three years.

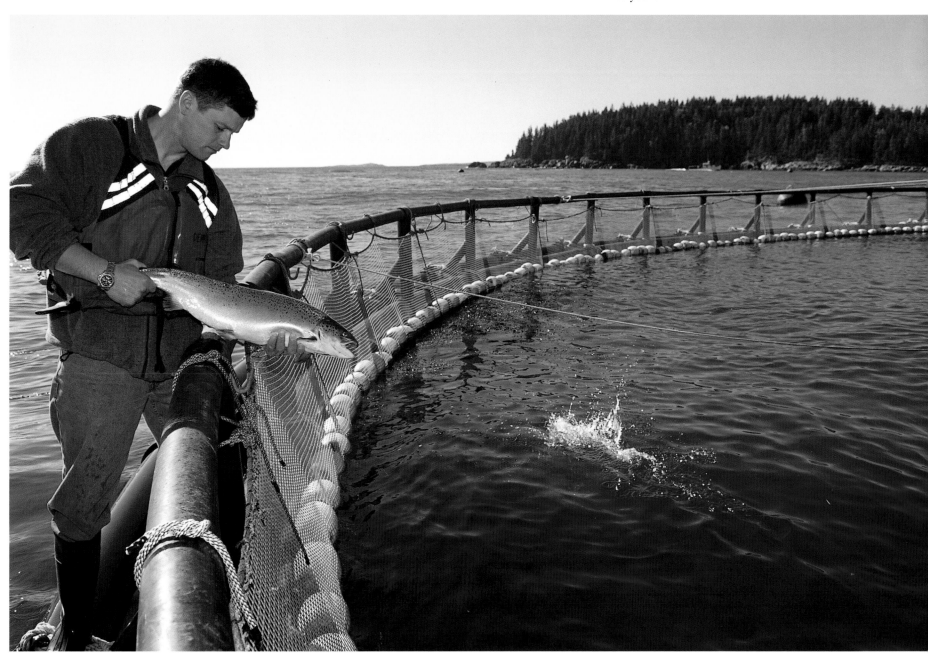

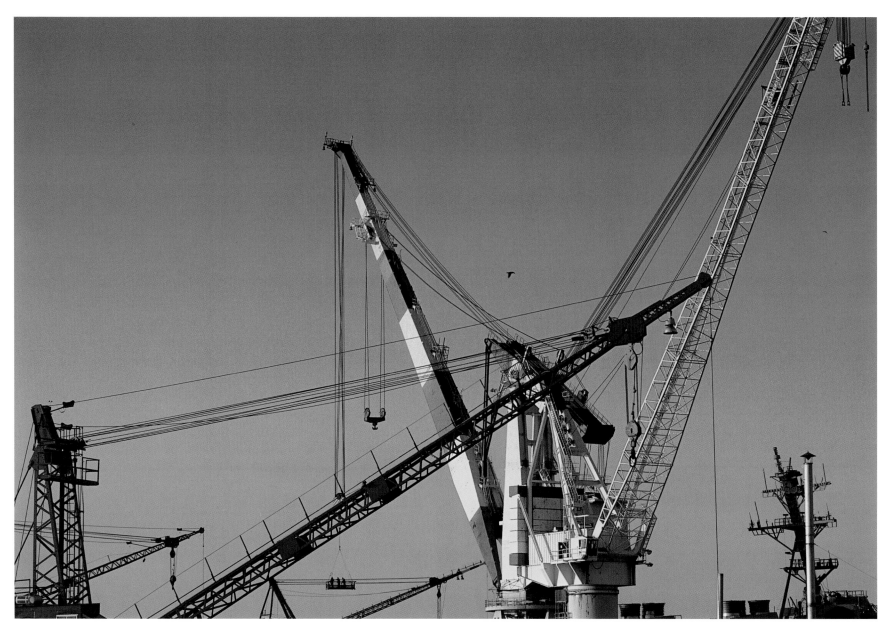

Bath Iron Works, located on the banks of the
Kennebec River in the city of Bath, has been
building large, steel-hulled vessels since 1840.
During World War II, the yard produced eighty-
two destroyers—more than the output of the en-
tire Japanese empire. BIW's huge cranes, one of
which can lift three hundred tons, have long been
a landmark for travelers of Route 1. With more
than eight thousand employees, the shipyard is
the largest private employer in Maine.

America's antique defenses meet her most modern ones as the billion-dollar, BIW-built, Aegis-class destroyer USS *Winston S. Churchill* heads to the open ocean for sea trials, passing Fort Popham at the mouth of the Kennebec River. Finished in 1865, the fort was designed to prevent any incursion by the Confederate navy during the Civil War.

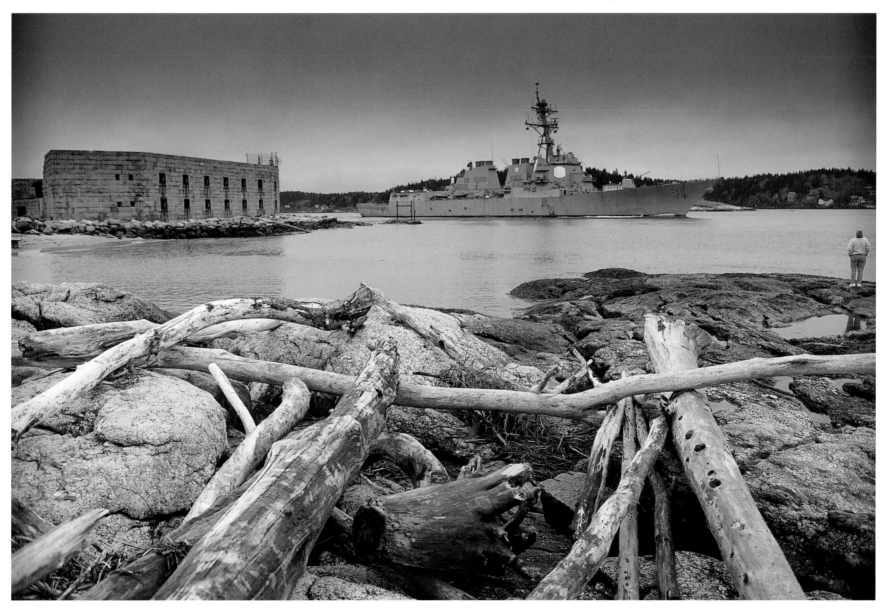

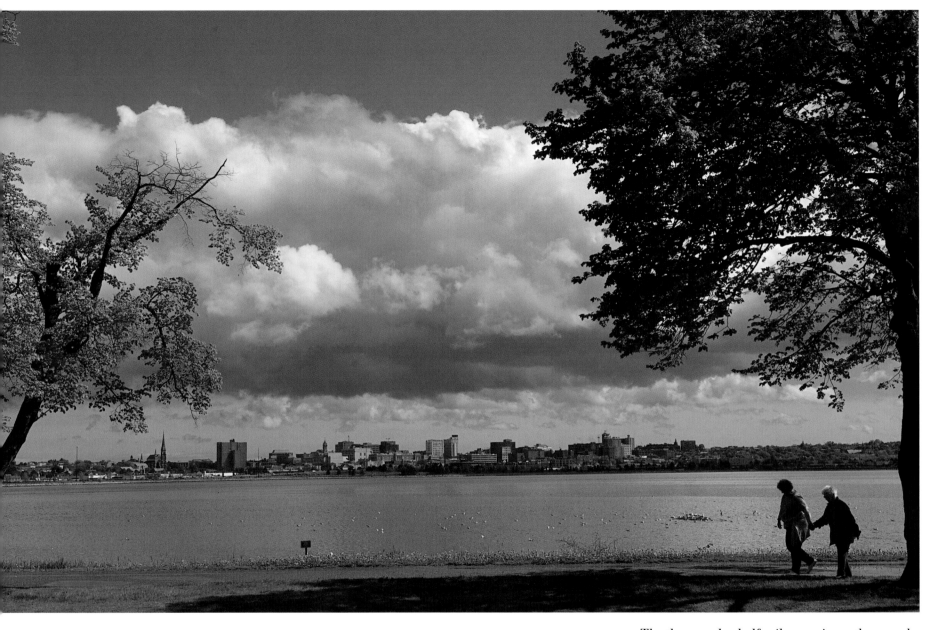

The three-and-a-half-mile exercise path around Back Cove in Portland is part of the city's growing Greenway network. Connected to the one-and-a-half-mile Eastern Promenade trail, this walkway is vigorously used in all four seasons—particularly in the spring, when the snows are gone. Portland is blessed with many parks and more than thirty miles of trails, a number of which are plowed in the winter, giving the city its pedestrian-friendly reputation.

Held annually in early June, the Old Port Festival is a family-oriented event that includes a grand parade, free activities and entertainment, ethnic foods, and music ranging from country to jazz to rock. The festival is designed to attract visitors to the old city center, a five-block area along the waterfront featuring a great variety of cafés, quaint stores, brick sidewalks, and cobblestone streets.

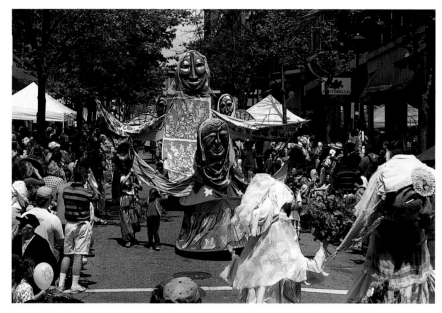

The Portland Sea Dogs, playing at the city's Hadlock Field, are the AA farm team of the Florida Marlins, and they are a major attraction in town during the baseball season.

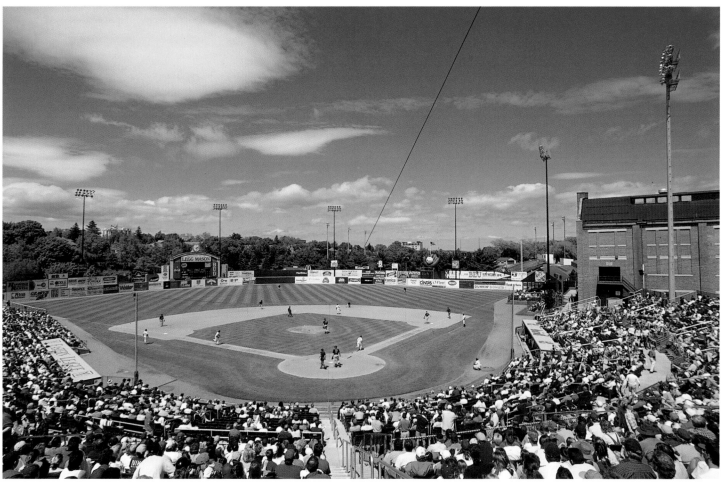

Eighth-graders from South Bristol await the launching of wooden skiffs they have just completed in a boatbuilding program at the Maine Maritime Museum in Bath, which recognizes that there are ways to teach history other than offering exhibits. Maine has always taken great pride in its rich maritime heritage, and the Maritime Museum is one of the finest repositories of the state's nautical history.

Eartha, the world's largest revolving globe, rotates inside the DeLorme Mapping Company building in Yarmouth. Built on a scale of one inch to nearly sixteen miles, it is exactly one millionth the size of Earth. The globe stands three stories high, is forty-one feet in diameter, and weighs 5,600 pounds. Standing beside Eartha as it revolves is a hypnotic experience, giving one a sense of geography available nowhere else but from a point in space.

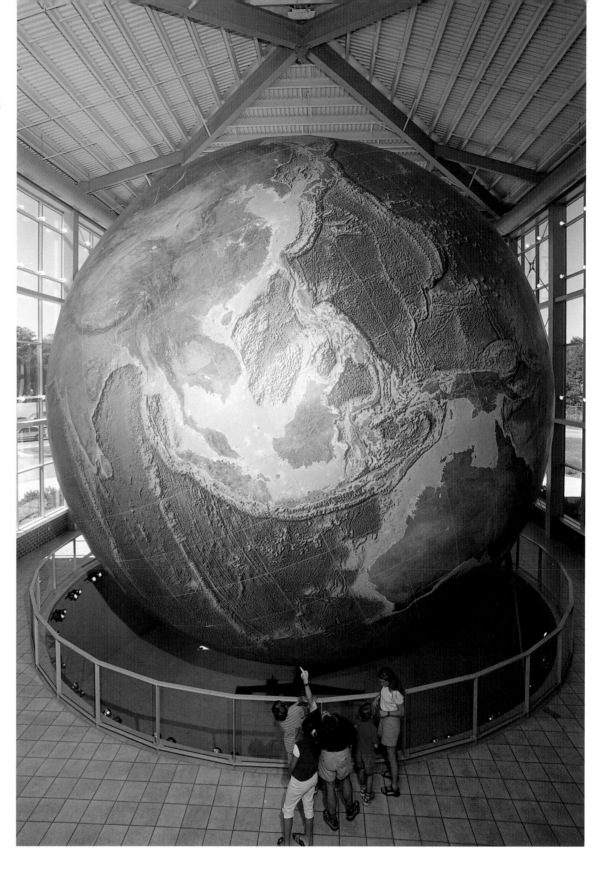

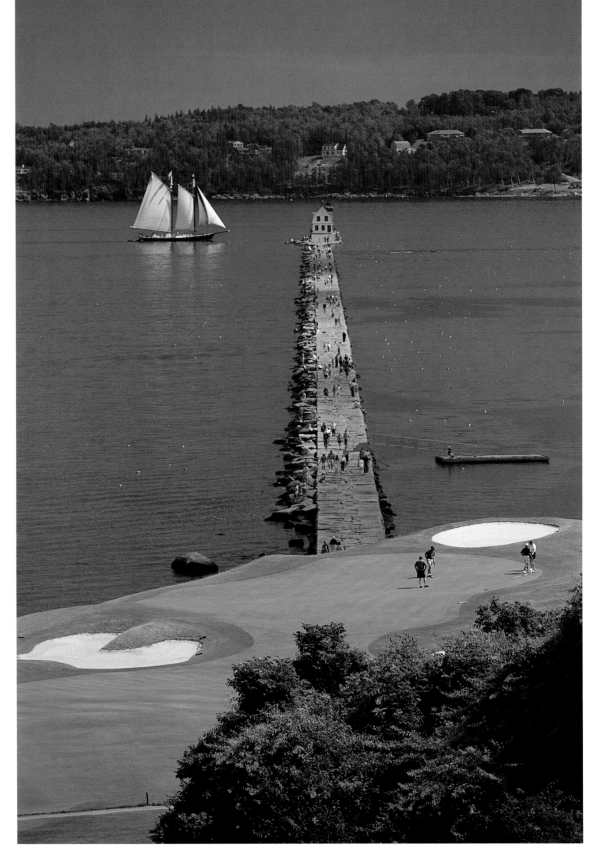

By late spring, outdoor activities begin in earnest. Maine's fleet of windjammers sets sail on cruises ranging from three to six days and day trips as short as two hours. Golf courses, both public and private, gear up for a short but busy season. Schooners and sand traps converge at the entrance of Rockland Harbor, which is famous for its 4,346-foot-long breakwater, an eighteen-year project begun in the late 19th century. The structure incorporates nearly seven hundred thousand tons of granite blocks.

Leaf-out time is the perfect moment (and it truly seems to last only a moment) to see the 18th- and 19th-century architecture of Maine towns like Searsport. Now home of the Penobscot Marine Museum, this waterfront community flourished in the mid-1800s from riches garnered through boatbuilding and the China trade. Reflecting this worldly heritage, the First Congregational Church boasts a Christopher Wren steeple and Tiffany glass windows.

Across the state to the west, in South Paris, the McLaughlin Gardens spring into bloom with ninety-eight varieties of lilacs plus multitudes of other flowers, making for a brilliant, summer-long display.

The Maine Wildlife Park in Gray is managed by the state's Department of Inland Fisheries and Wildlife as an educational center and as a home for injured or orphaned wildlife like this white-tailed fawn. The naturalized exhibit spaces allow visitors excellent chances to view and photograph everything from black bears to bald eagles.

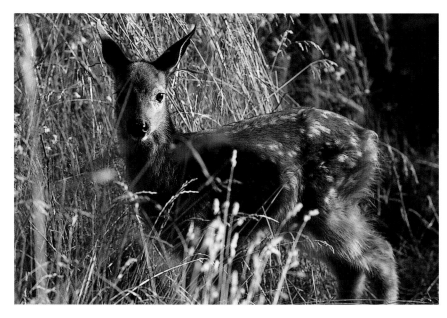

Kayakers on Casco Bay, which extends from Cape Elizabeth to the Kennebec River, see a lot of variety, due in part to the bay's 136 islands. These are known collectively as the "Calendar Islands" because it was long thought that 365 of them dotted these waters at low tide.

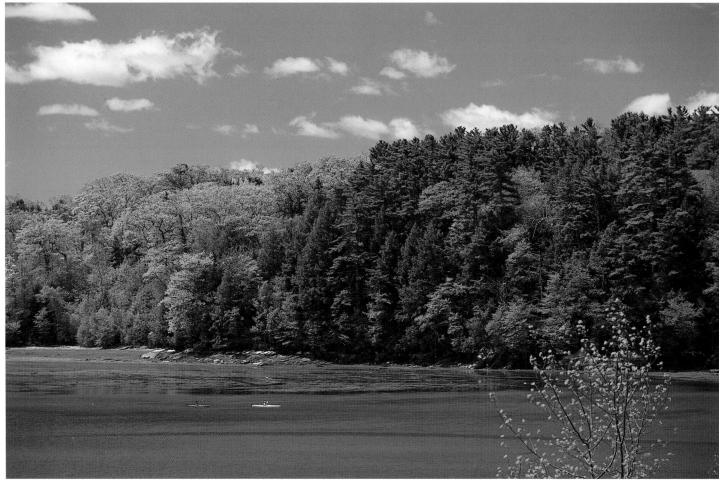

SUMMER

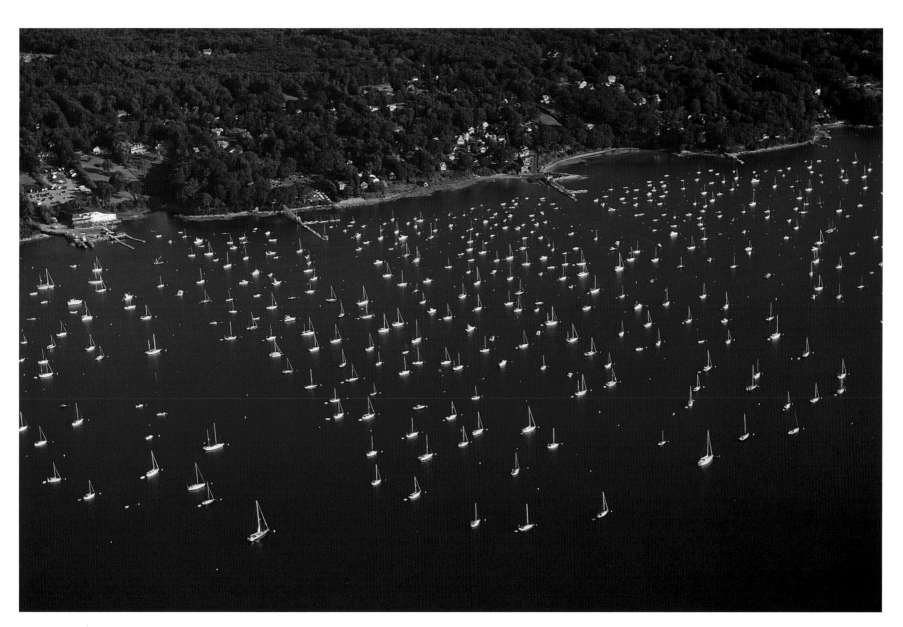

Local residents know that summer has arrived
when the moorings along the Falmouth shoreline
sprout all varieties of sailboats and motor vessels.

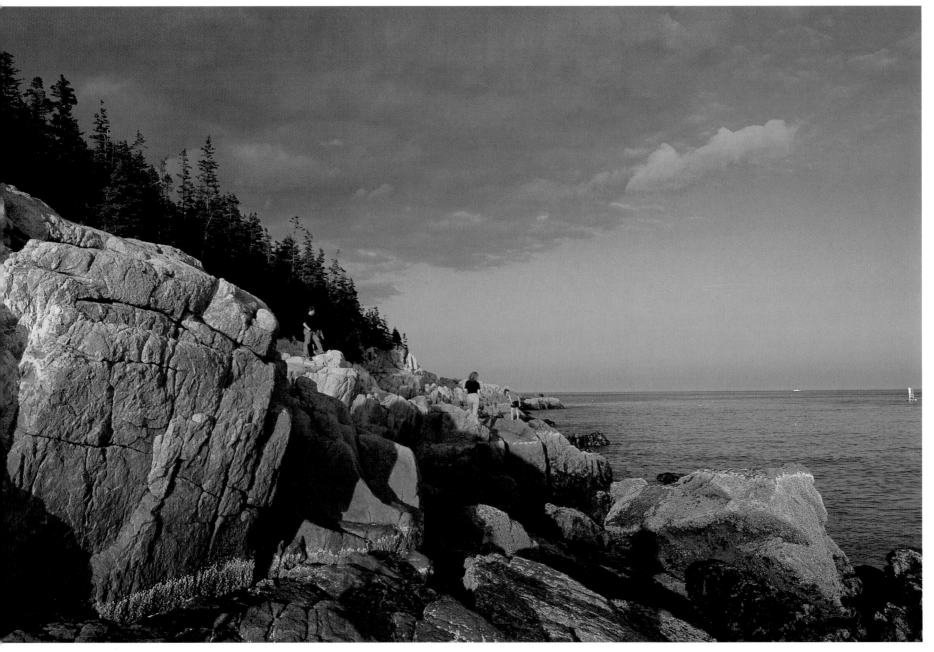

The pinkish granite of Bass Harbor Head glows in the sunset. Famous for its lighthouse, this headland is located on the southwestern tip of Mount Desert Island's Acadia National Park, the second most visited national park in the country. This is Sarah Orne Jewett's "Land of the Pointed Firs," where signature evergreens rim the coast and islands.

What could better exemplify the state's unofficial motto—"Maine, the way life should be"—than a morning of family fun spent picking the juiciest, sweetest strawberries imaginable. Whether at this farm in Cape Elizabeth or at similar sites throughout the state, "pick your own" harvesting is popular everywhere in Maine.

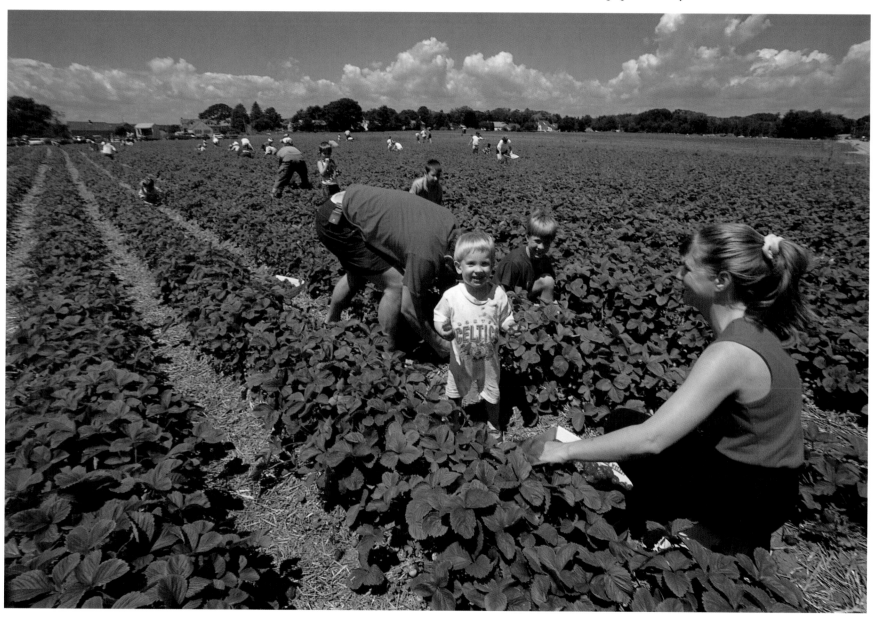

After nibbling wild blueberries on their way to the summit, hikers enjoy the view from atop Acadia Mountain, across the entrance of Somes Sound, to the Cranberry Isles and the broad Atlantic beyond.

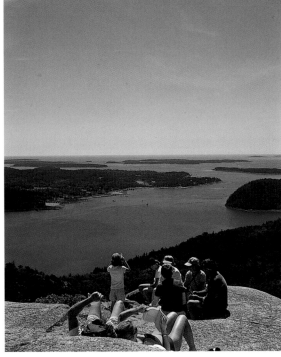

Acadia National Park's forty thousand acres offer outdoor enthusiasts a wide variety of terrain. These hikers are on the side of Acadia Mountain (681 feet), while behind them is the shoulder of Norumbega Mountain (862 feet). Between the two peaks—out of sight—lies deep, narrow Somes Sound, the only true fjord on the East Coast.

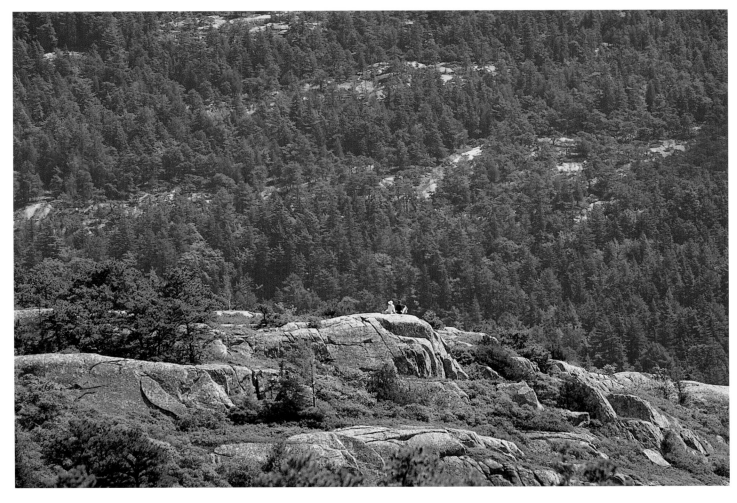

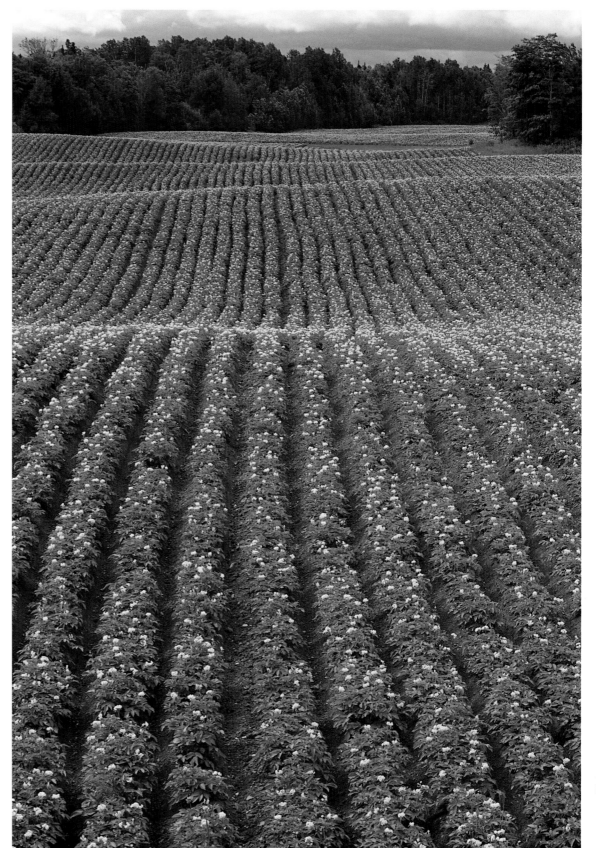

Maine agriculture thrives in Aroostook County, which is larger than Connecticut and Rhode Island combined. When they are in bloom, the rolling potato fields are a spectacular mid-summer sight. Farmers in "The County" produce over two billion pounds of potatoes annually. Also prevalent are acres of broccoli and grain crops, as well as huge, chrome yellow plots of rape, grown for animal feed.

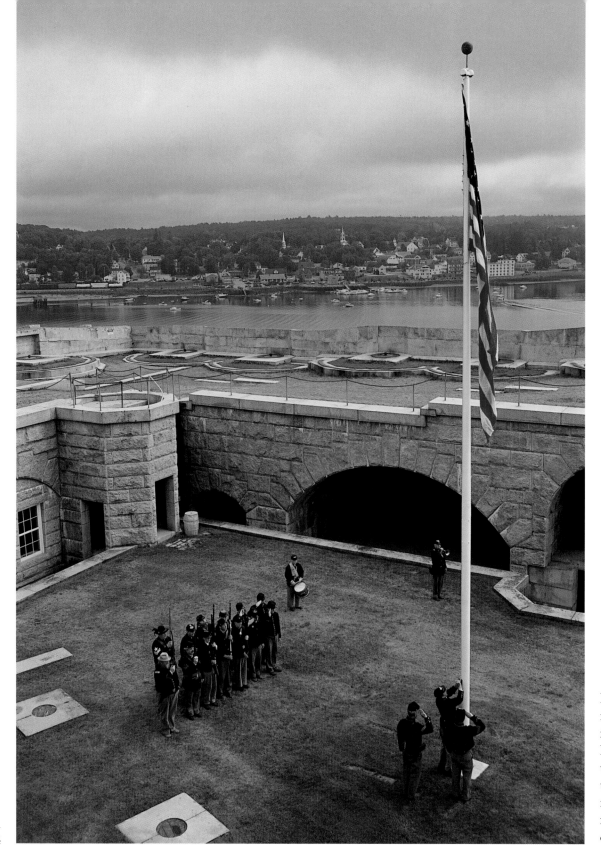

In Maine, Fort Knox is not a gold repository but rather a half-completed fortress that took shape in the mid-19th century at the mouth of the Penobscot River, across from Bucksport. On certain summer weekends, modern-day members of the 20th Maine Volunteer Infantry Regiment recreate the sights and lifestyle of a hundred and fifty years ago with displays of Civil War military drills, cooking, and camp life.

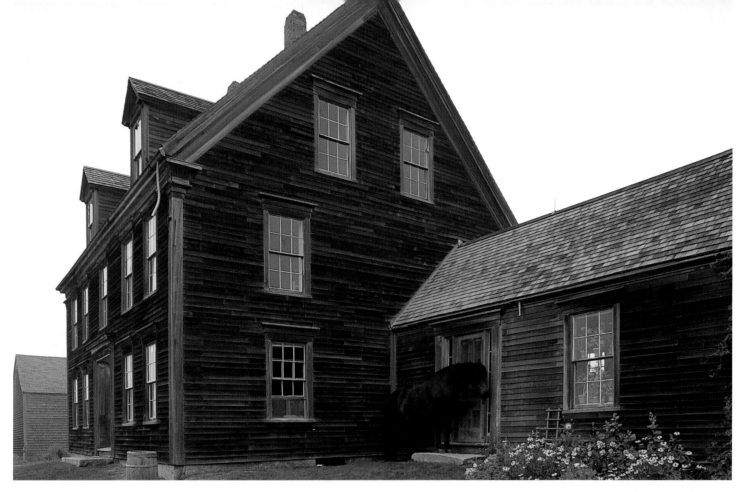

Made famous in Andrew Wyeth's painting
Christina's World, the Olsen House in Cushing is
now maintained by the Rockland-based
Farnsworth Art Museum much as it was when
Wyeth painted here.

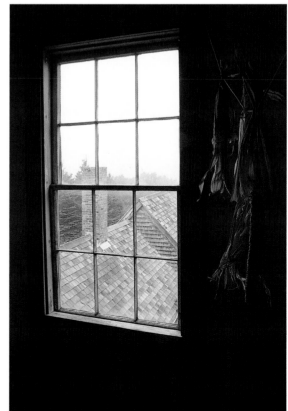

The interior's unadorned rooms, which also in-
spired many of Wyeth's well-known works, are
still filled with the soft, spare light he so ably cap-
tured.

Dice Head Light, now decommissioned and privately owned, crowns the tip of the Castine peninsula, where its location and views have inspired artists over the years. All of Maine's more than sixty lighthouses are now automated, but the romance of the lonely, heroic keeper and his family remains alive in stories and folklore. The structures themselves are preserved under Senator Olympia Snowe's "Maine Lights" initiative and are maintained by private organizations.

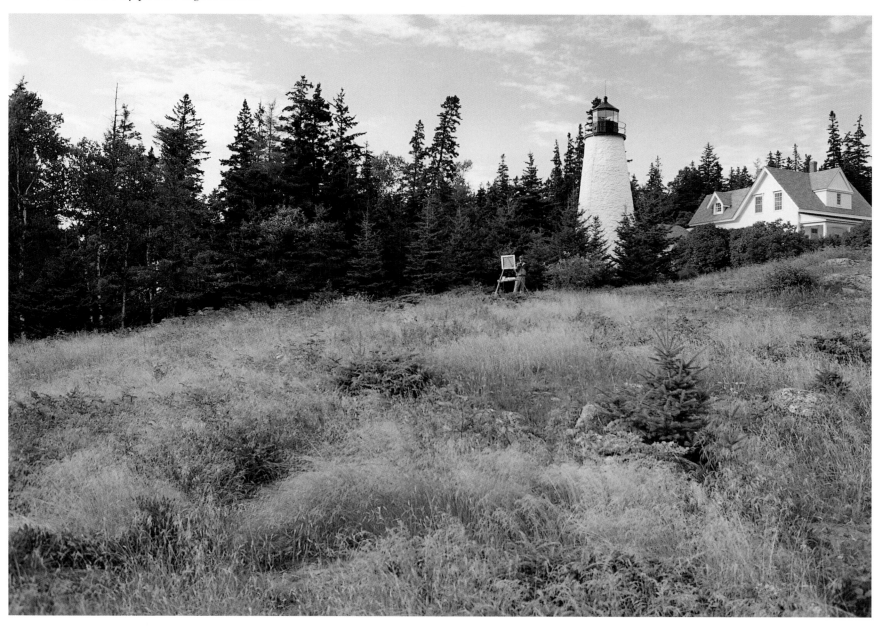

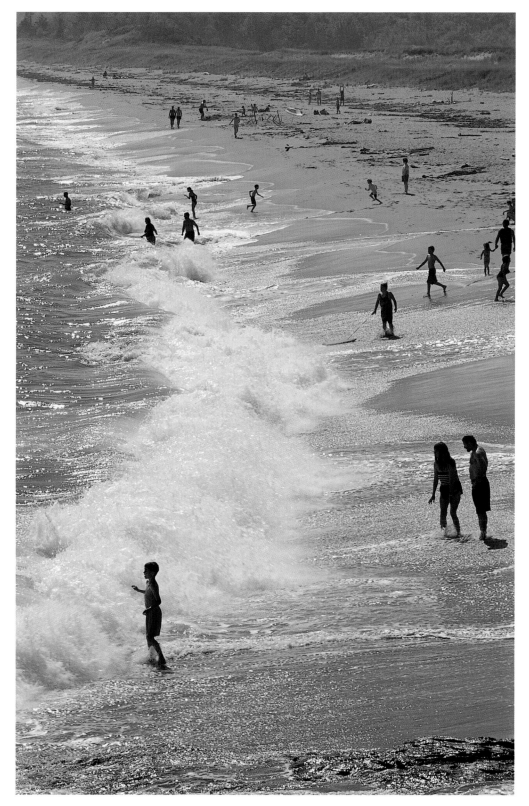

The fishing can be good from the Eastport pier on Passamaquoddy Bay, where the tidal range may be as great as eighteen feet. Not every catch, however, makes delicious eating.

With their temperatures often hovering around sixty degrees, Maine's brisk ocean waters offer plenty of stimulation. While the cliché for the state's coastline is "rock bound," there are some astonishingly beautiful sandy beaches between the New Hampshire border and Roque Island. Reid State Park, at the mouth of the Sheepscot River in Georgetown, is but one example.

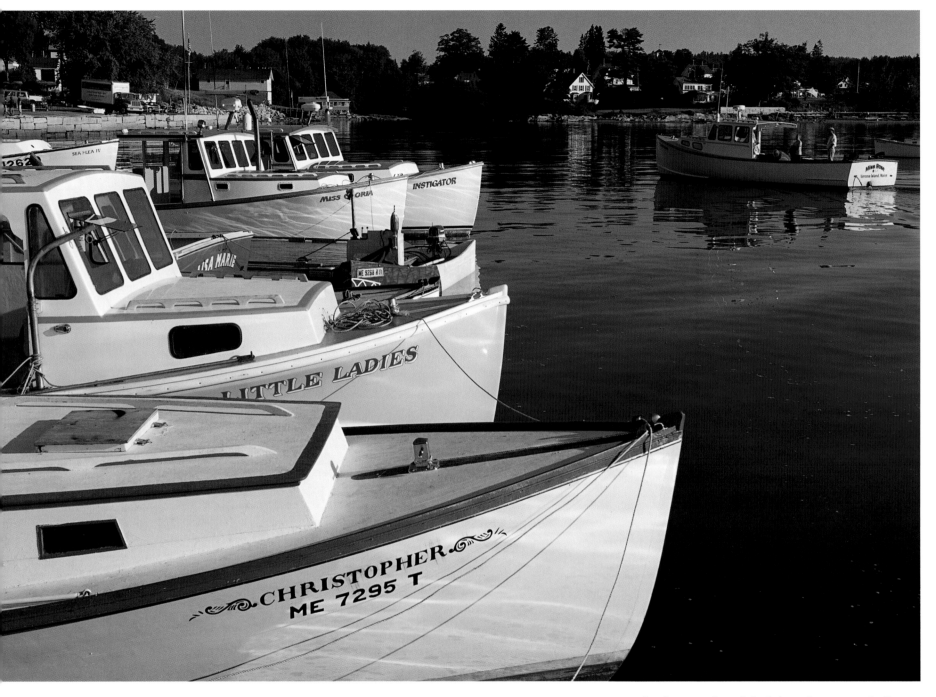

On the morning of the lobsterboat races in Searsport, competing vessels raft cozily in the early light. Efficiently designed with high bows to cut through seas and with low sterns for easy trap handling, these boats truly exemplify the theme "form follows function."

Racing lobsterboats is a popular sport along the down east coast on summer weekends. Here, in Penobscot Bay off Searsport, local fishermen and boatbuilders gather to test their vessels in a favorite ritual. Some are unmodified workboats, while others are floating stock cars, featuring huge engines and special construction.

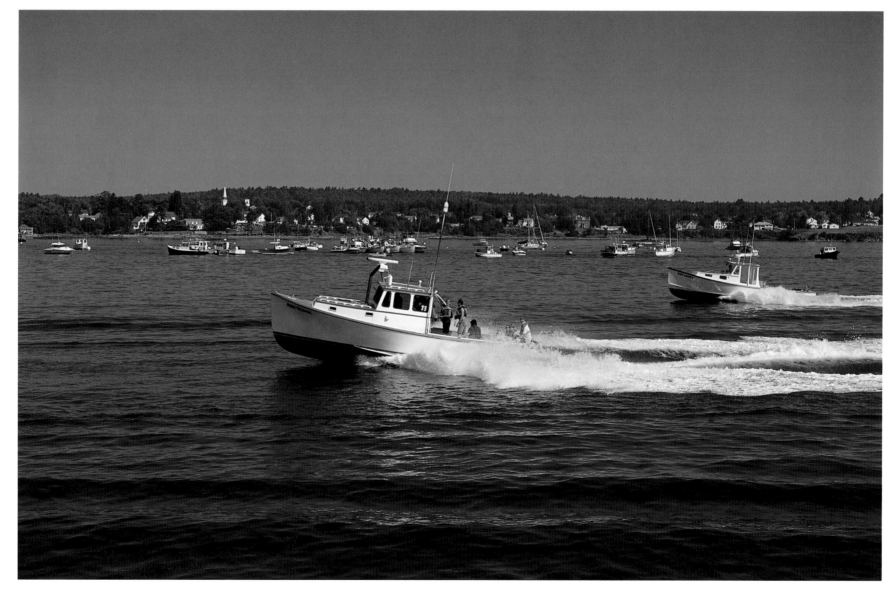

Just south of Rockland is the Owl's Head Transportation Museum, where one can often see vintage aircraft put through their aerobatic paces. Along with antique flying machines, there is an impressive collection of other vehicles, from an 1868 bicycle to a 1980 Penske Indy car.

Certain summer weekends are reserved for special events at the museum. In this case it is a gathering of classic cars from the '50s and '60s. Some five hundred vehicles participated in this event.

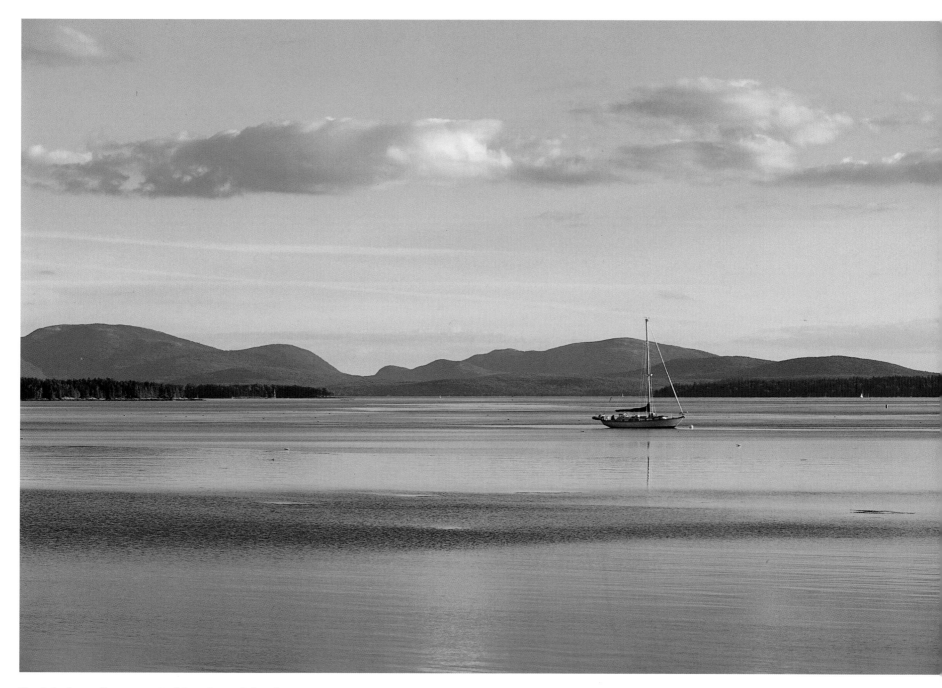

Dusk in Long Cove, overlooking the mainland on
Mount Desert Narrows, brings a day of cruising
to an end. Maine's more than five thousand miles
of coastline and roughly four thousand islands
(the numbers differ radically, depending on the
tide) make the state's waters prime territory for
yachtsmen the world over.

Long Sands Beach, in the southern Maine town of York, is one of the state's most accessible beaches. It is especially popular on hot summer days, as the gentle slope of the sand allows the sun to warm the otherwise chilly water to a comfortable temperature.

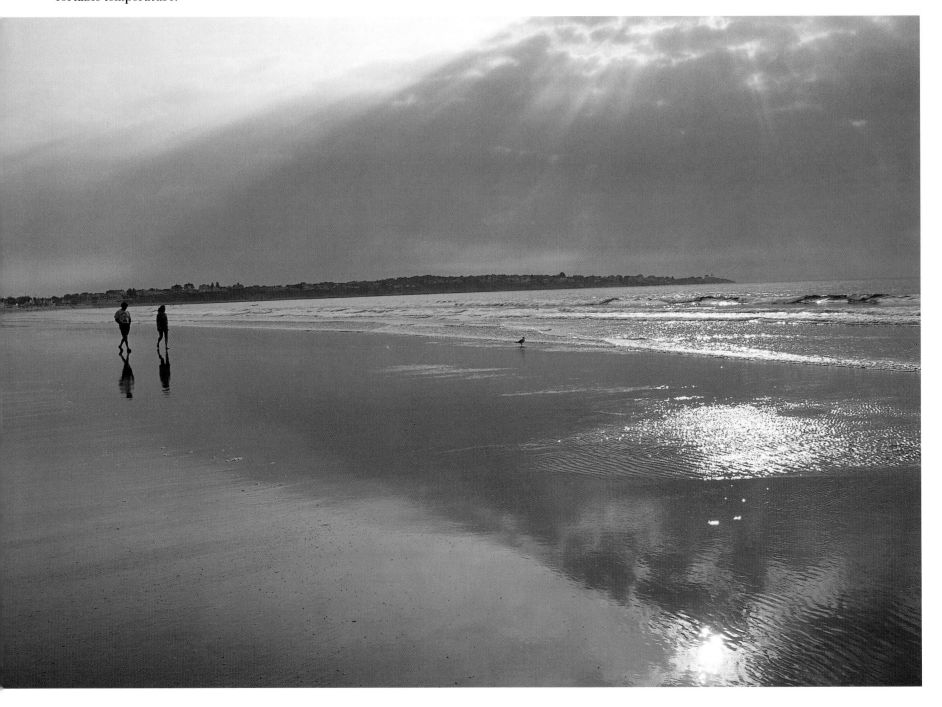

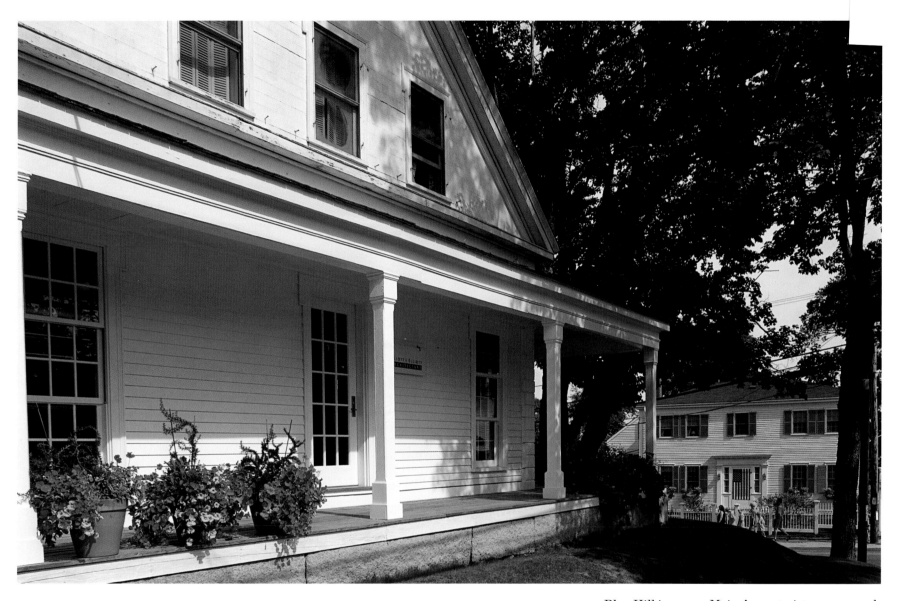

Blue Hill is among Maine's most picturesque and quiet towns. A cultural center for the area, it has a rich program of summer music. The town is also the September home of the Blue Hill Fair, made famous in part by the late local writer E. B. White in his classic *Charlotte's Web*.

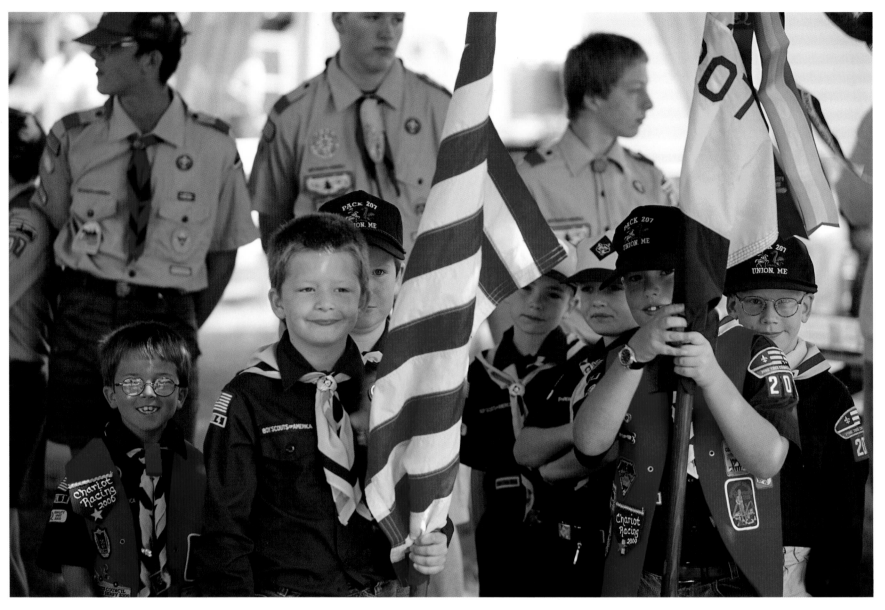

Summer is the time each year when Maine starts celebrating its agriculture. The week-long Union Fair opens with a formal flag-raising by local Brownies, Cub Scouts, Boy Scouts, and Girl Scouts. These events are very successful in bringing the consumer and the farmer together, and in educating the public—especially children—in the ways of raising food. Twenty-four agricultural fairs are held in Maine between July and October, when the giant, week-long Fryeburg Fair brings these expositions to a close.

Summertime fairs and other events can be found in a variety of flavors all over Maine. The Machias Blueberry Festival, in the heart of wild-blueberry country, is famous for its "hands off" pie-eating contest.

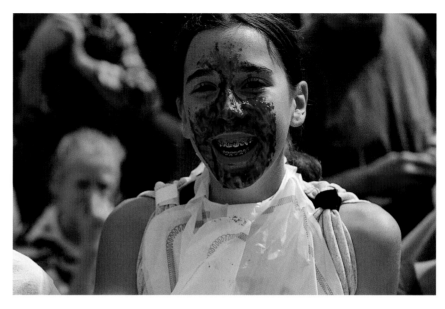

Horse pulling at the Cumberland Fair, held "Always in September" since 1871, is an impressive experience. Working singly or in teams, these massive draft horses, some weighing close to a ton, drag increasingly weighted sledges until all but the strongest are eliminated. There always seems to be a feeling of unity among the contestants at these events, a community spirit that brings out the best in everyone.

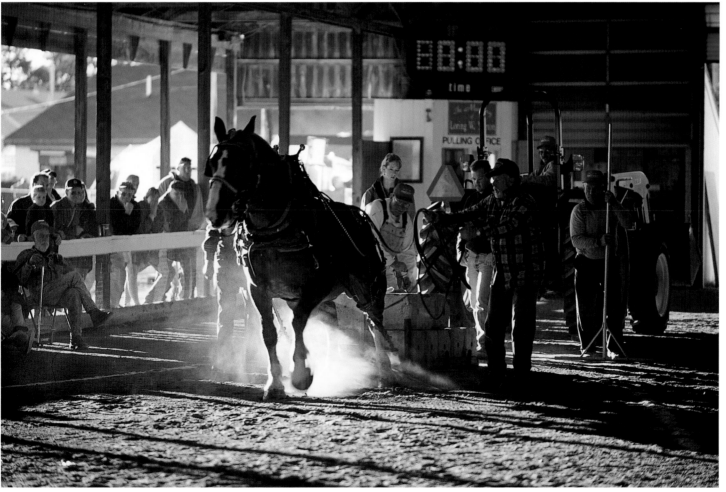

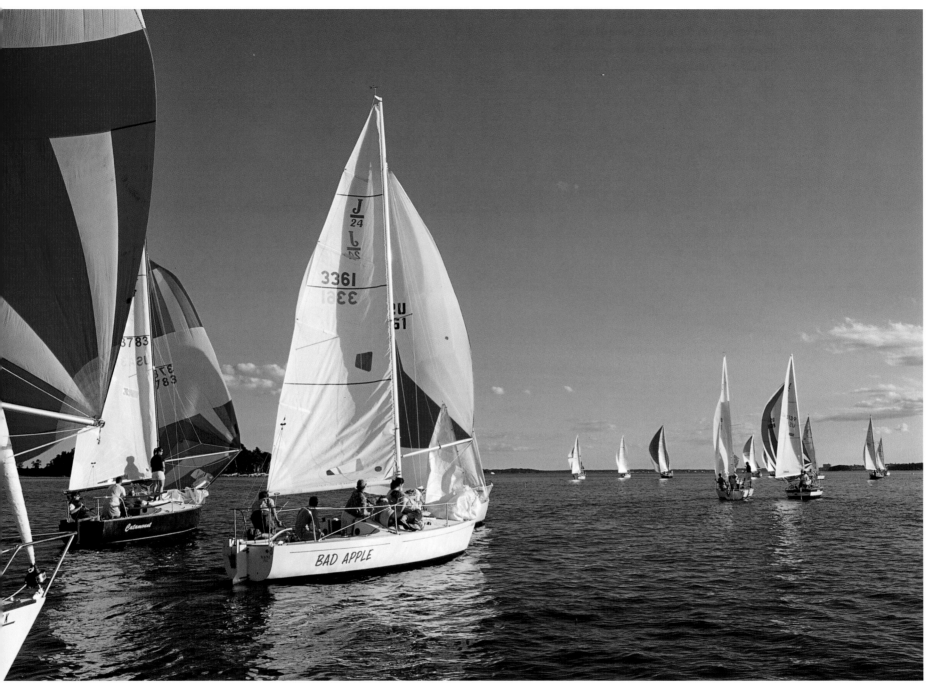

Taking part in the weekly Thursday night race at the Portland Yacht Club on Casco Bay is an especially delicious way to end the work day on a glorious August evening. Several classes of boats compete in these friendly, relaxed contests—and everyone wins at the celebratory cookout.

Fog forms over the coastal waters when warm, moist air settles on the cold ocean surface. While up-to-date electronic navigational systems like GPS help yachtsmen and commercial fishermen pinpoint their location under the worst conditions, some find the poor visibility a great excuse to stay ashore and train a bird dog for the upcoming hunting season.

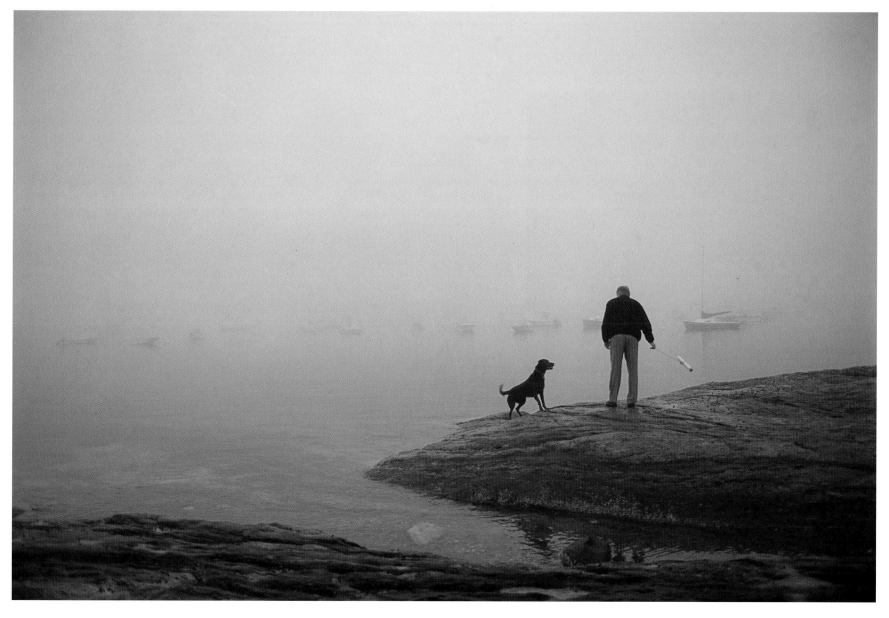

On a treeless, seven-acre dot of granite named Eastern Egg Rock in the middle of Muscongus Bay, the Audubon Society has successfully reestablished a puffin population ninety-six years after the last known colony here was decimated. Young birds are weighed, measured, and banded so that their movements can be traced. Also underway at Eastern Egg Rock is a promising effort to reestablish the endangered roseate tern.

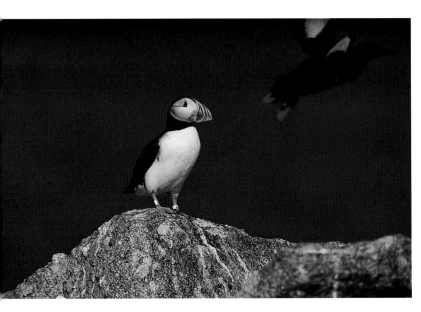

A guillemot wings past a puffin, the harlequin of the seabird world. At about one-and-a-half pounds, the lovable puffin is the size of a pigeon, but its short, stubby wings—better adapted for swimming than flying—give it the aerodynamics of a sack of cement. It can, however, fly.

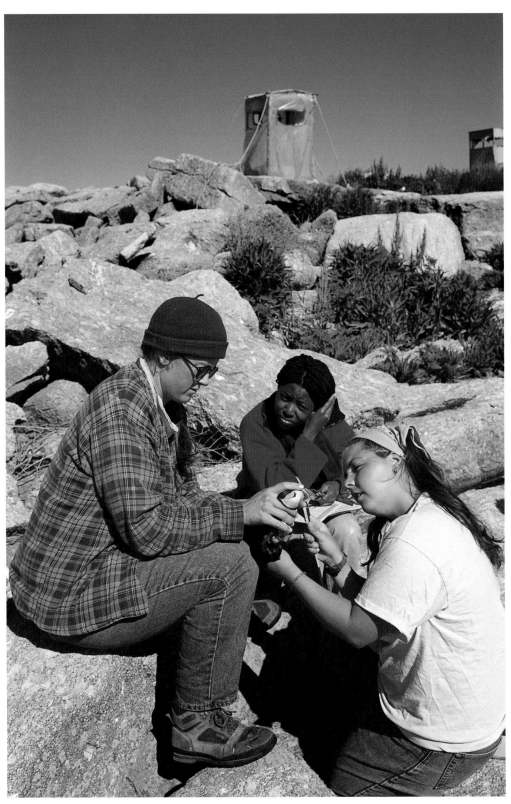

On the summer solstice, the sun rises before five A.M., burnishing a Rockland fish-processing plant with its golden glow. Renowned as a shipbuilding and fishing port in the 19th century, the city fell on hard times in the 1990s as New England groundfish stocks were severely depleted. Rockland is currently undergoing a renaissance, sparked by the Farnsworth Art Museum, the windjammer fleet, new high-tech employers, and the local lobster fishery. Some ten million pounds of lobster are shipped from the city every year.

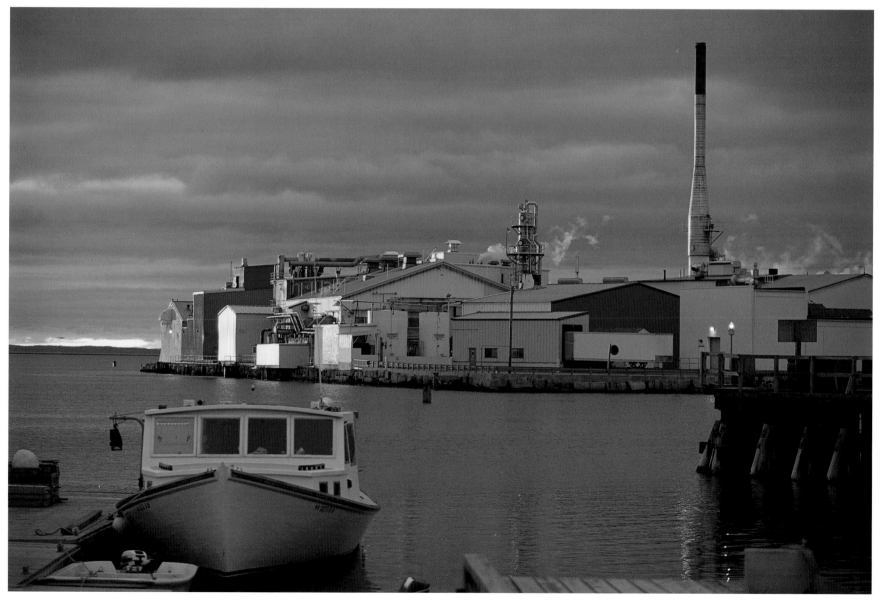

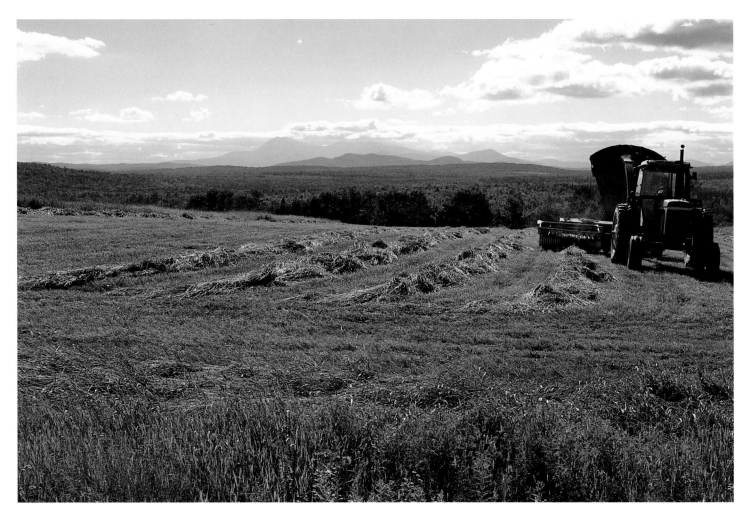

Few hayfields offer as beautiful a view of Katahdin as this one in Patten. Picturesque though it may be, farming in Maine is tough, uncertain work, with mercurial weather being the major unknown factor.

Today, due to consolidation, retirement, and/or development pressure, the number of Maine's family farms has greatly dwindled. Those who continue the tradition, however, do so with wry humor, Yankee determination, independence, and—most important—a true love of the land.

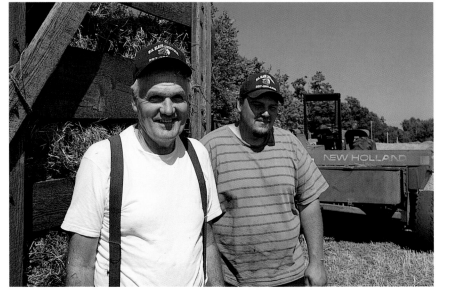

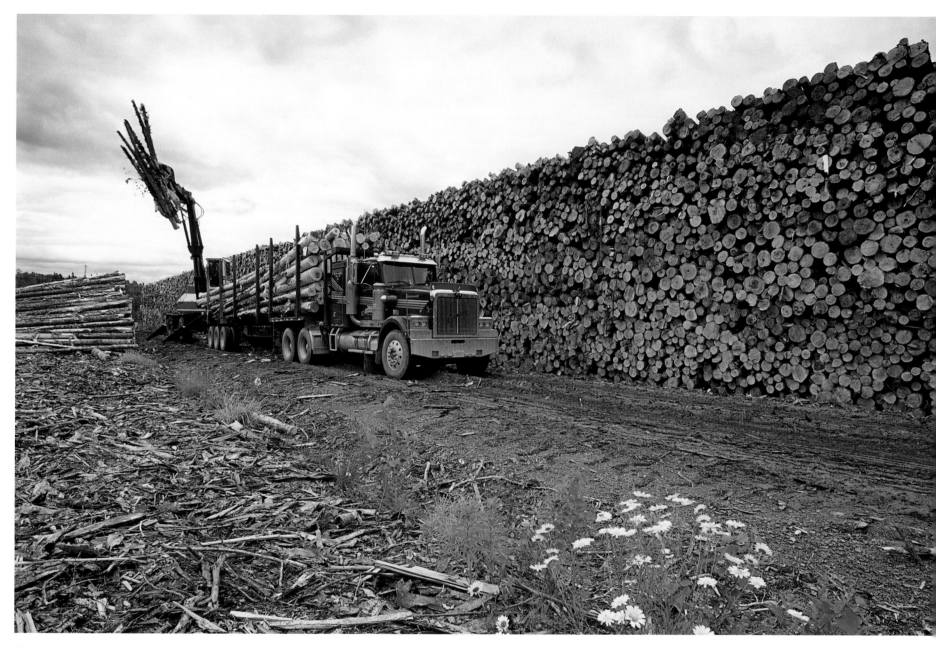

With 89 percent of its land covered by forest,
Maine is America's most wooded state. Most of
the timber, such as these logs being yarded in
Ashland, is used in the pulp and paper industry.
Including everything from balsam fir tips used in
wreath-making to high-quality hardwoods like
oak, the forest-products industry adds $6 billion
to the state's economy. Tourism, at $3.8 billion, is
the second largest contributor to Maine's coffers.

No summer in Maine is complete without a lobster bake. Besides the tasty crustaceans, shoreside feasts like this one, in Boothbay Harbor, generally feature steamed clams with broth, baked potatoes, corn-on-the-cob, salad, and maybe wild-blueberry upside-down cake. Everyone has a "wicked good" time.

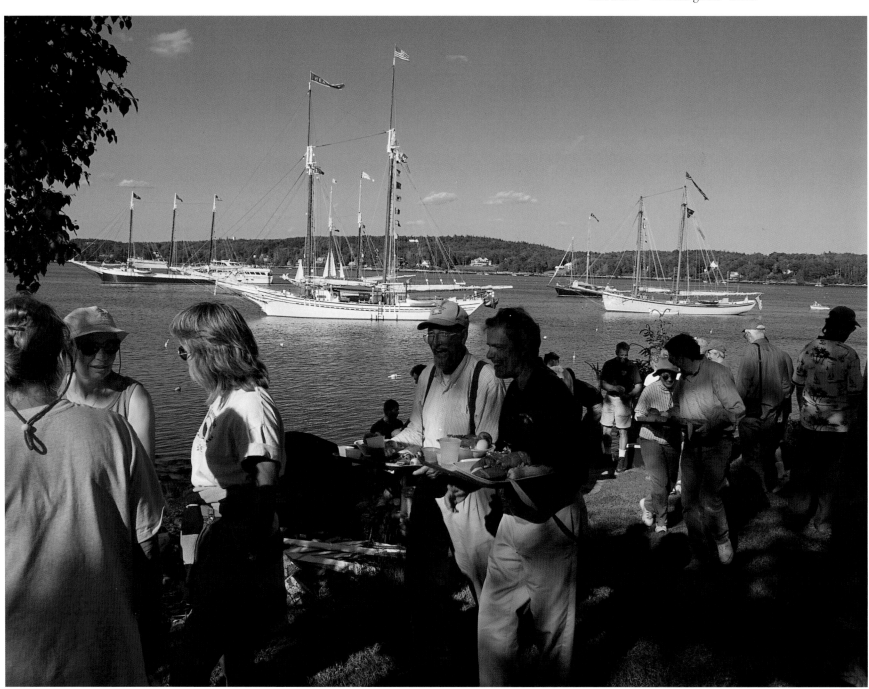

Penobscot Bay is home to most of the state's windjammer fleet. Although some of these tall-masted wooden sailing ships are reproductions, many were originally built to haul freight up and down the coast before the days of power. Still lacking engines, they are maneuvered when necessary by auxiliary push-boats. To sail aboard a windjammer is to step back to a slower time punctuated only by the slap of waves, the snap of canvas, and the singing of wind in the rigging.

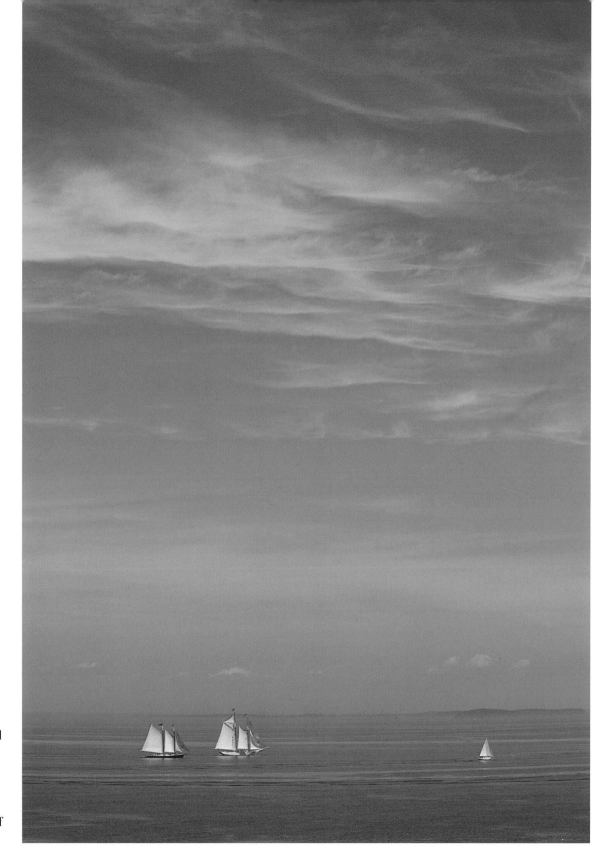

Many towns in Maine have a village green, a holdover from Colonial days, when the local cattle were kept in a central area. Retail giant L. L. Bean has created such a space in front of its flagship store in Freeport and regularly sponsors evening concerts, art shows, and other events during the summer—free to all comers.

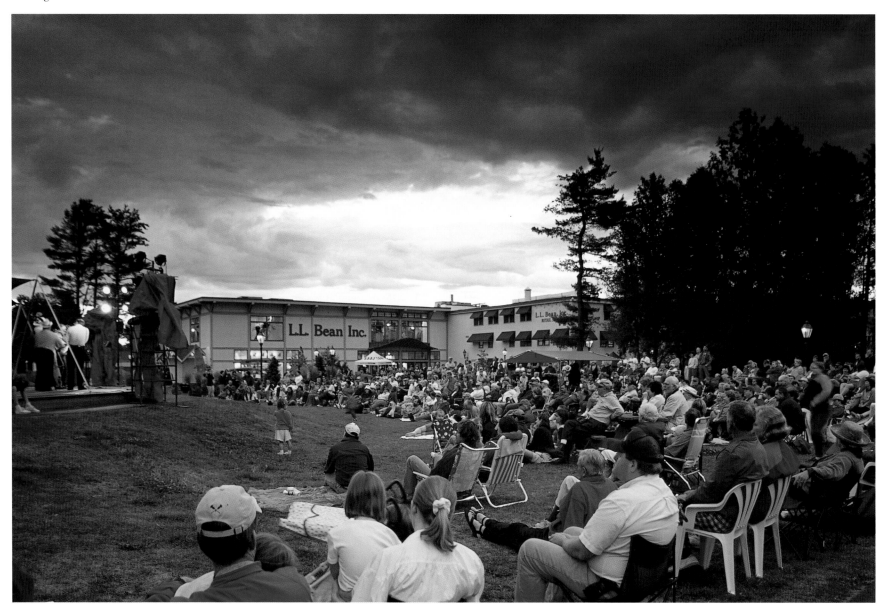

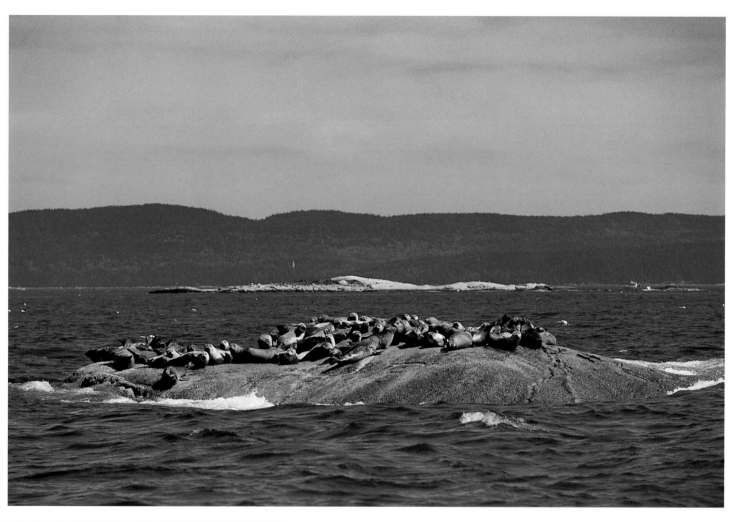

Along the neatly scrubbed granite and pine islands called Merchants Row, strung between the fishing port of Stonington and Isle au Haut, harbor seals gather on a barren ledge to bask in the sun.

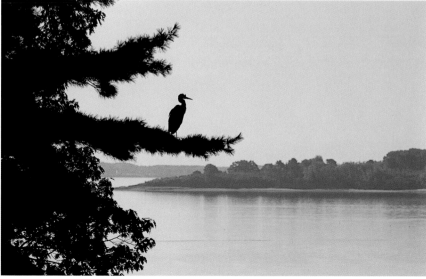

On the shores of Casco Bay, a stoic blue heron perches in a white pine, waiting for a meal to pass through the water below. Egrets, gulls, terns, eagles, ospreys, and waterfowl are among the varied bird life seen along the coast of Maine.

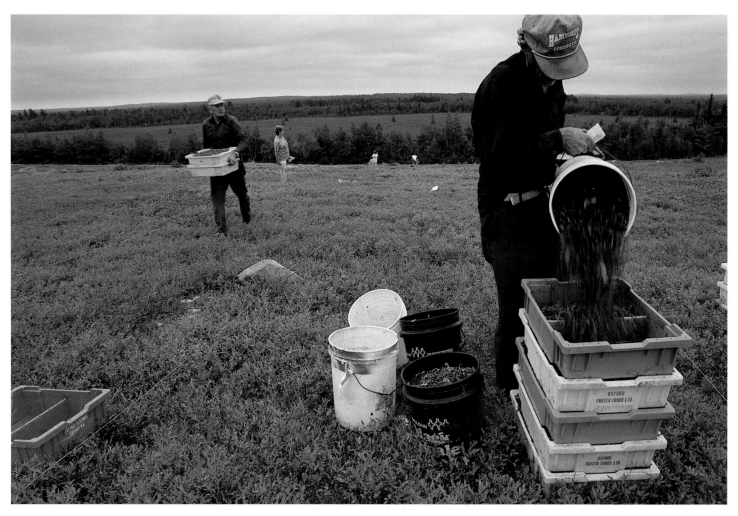

Wild, low-bush blueberries—tamed by canny Mainers—are big business in economically hard-pressed Washington County. Most of the berries are harvested manually with rakes that skim the fruit from the plants.

Wild blueberry plants grow about a foot off the ground, and while the berries are smaller than those of the cultivated, high-bush variety, they are much sweeter and more flavorful. Maine produces more than 98 percent of the U.S. crop of low-bush blueberries and ships them around the world.

The lighthouse at the entrance to Portland Harbor's ship channel is Portland Head Light, whose beacon shines from a point 101 feet above the roiling surf. Looking seaward from the tower's hurricane deck, one can see some two hundred of Casco Bay's islands. On the land side, Portland Head Light is surrounded by ninety-four-acre Fort Williams Park, a former military post decommissioned after World War II.

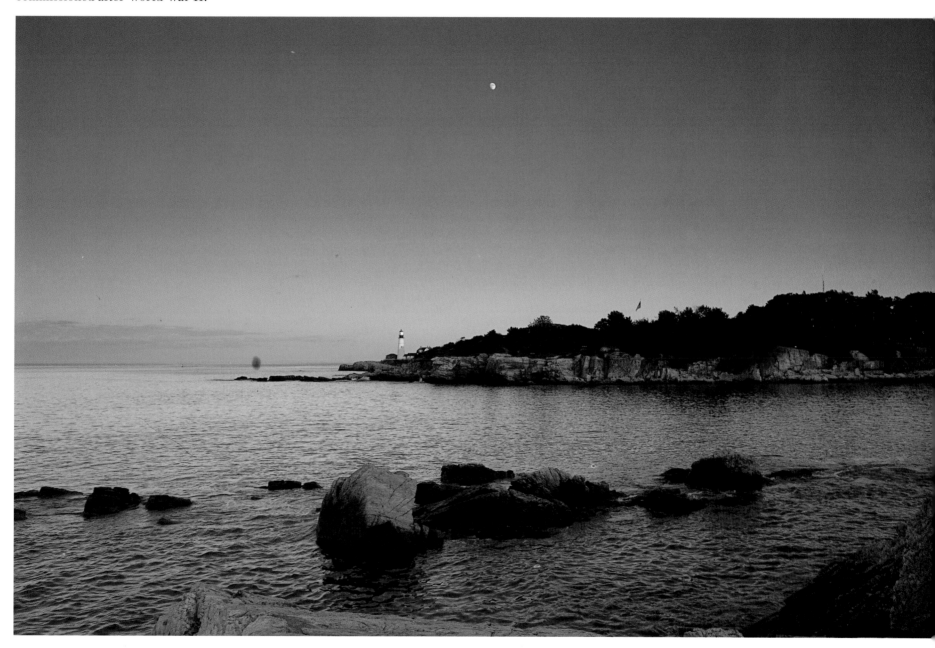

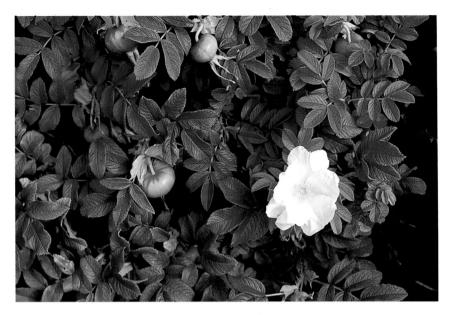

Rosa Rugosa grows wild along many stretches of Maine's coastline and is often the "last rose of summer." The hips, or fruit, from this shrub are rich in vitamin C and are used to make delicious beach-plum jelly.

Farm stands are a common sight along Maine's highways and byways in the summer and fall. They range in style from permanent structures that also sell ice cream and baked goods to a wheelbarrow manned by freckle-faced eight year olds selling their summer squash and tomatoes.

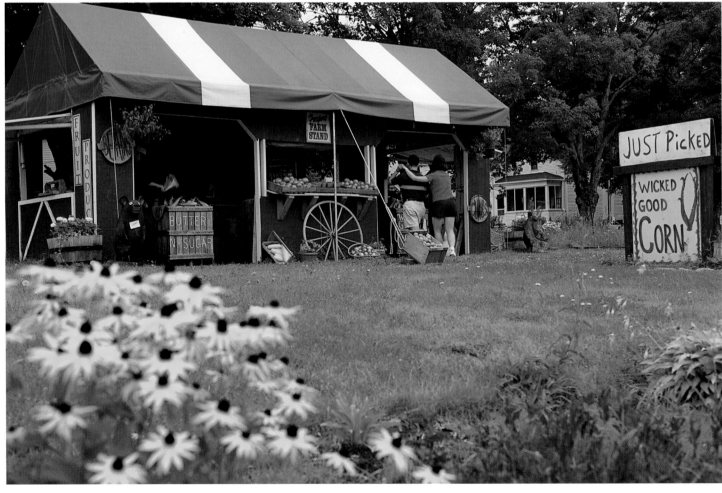

Early October foliage graces the banks of the
Carrabassett River in Kingfield.

Remember when you were small enough to jump into a pile of leaves and not hit bottom? When someone else would rake up the mess? Fall is still a special season in Maine. The days are warm, the nights are cool, and the foliage is spectacular.

Paris Hill, in west-central Maine, is a community of unspoiled architectural treasures. Built on rise with spectacular views of the White Mountains, its cluster of 18th- and 19th-century homes was passed by when the railroad came through and the county offices were moved down to South Paris. Although isolated and rural, this tiny town has produced one vice president (Hannibal Hamlin, Abraham Lincoln's first), twelve U.S. representatives, two U.S. senators, three presidents of the Maine Senate, three speakers of the Maine House, and four Maine governors.

"Pick Your Own" is a sign often seen in farmers' roadside fields. From apples to pumpkins and blueberries to strawberries, harvesting fresh produce is a Maine tradition.

Some large farms, such as this one in Poland Springs, organize event-filled fall weekends that include wagon rides, petting zoos, and even Halloween-costume contests.

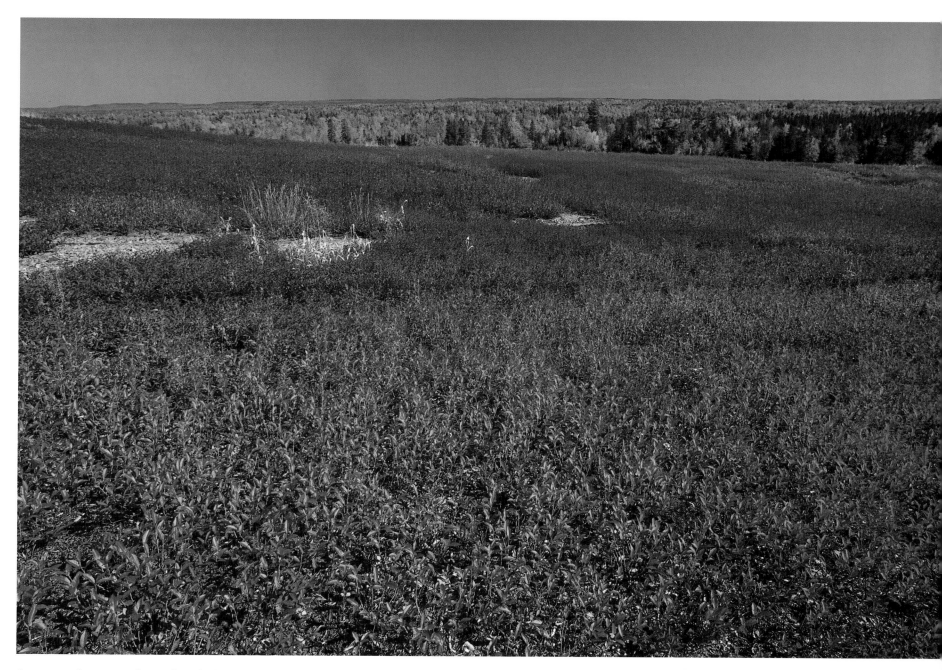

A canvas of green and purple only forty-five days
earlier, the blueberry barrens of Washington
County turn a brilliant scarlet, then dark red
with the shortening days and cooler weather.
That these crusty, glaciated acres can produce a
hundred million pounds of berries annually is
somewhat of a modern agricultural miracle,
aided by a great deal of Yankee ingenuity and grit.

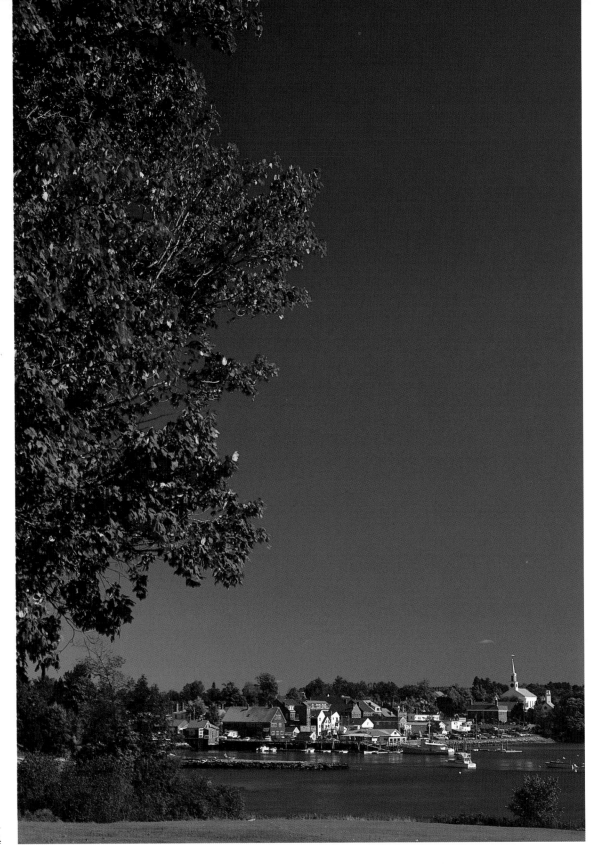

The town of Damariscotta, an Abenaki word meaning "plenty of herring," is perched on the banks of a river with the same name, some fifteen miles from the open ocean. Still, the place has all the charm of a seaside town. Damariscotta is also the entry point for beautiful Route 130, which wanders down Pemaquid Neck, ending at the much-photographed Pemaquid Light.

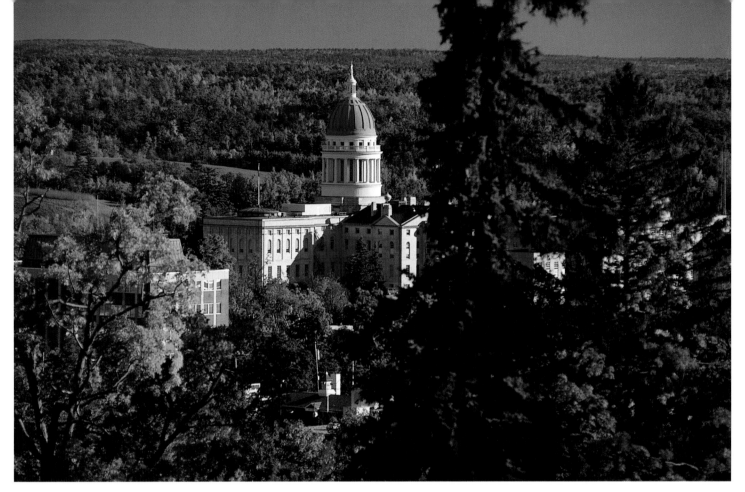

Though by no means a major urban center (it's only the seventh largest city in the state), Maine's capital, Augusta, is very much the seat of political life. Its location on the banks of the Kennebec River clearly reflects the central role that Maine's rivers played in developing the interior areas of the state.

Maine's flag, containing the figures of a farmer and a sailor and incorporating the Latin motto *Dirigo* (I lead), flies from the Lincoln County Courthouse in Wiscasset.

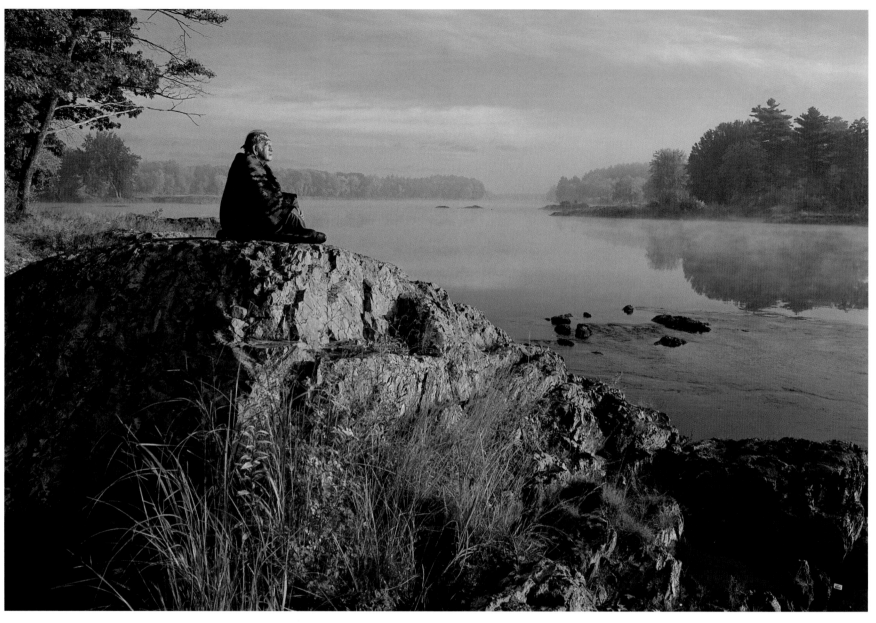

Meditating on the banks of the sacred Penobscot
River, like countless generations before him, a
Penobscot Indian elder meets the morning sun.
This rock, on Indian Island in Old Town, sits on
land held continuously by the Penobscot Nation
for thousands of years. Along with the Passama-
quoddy tribe and bands of Maliseets and Micmacs,
Maine's Native American population totals some
five thousand people, collectively known as the
Wabanaki or "People of the Dawnland."

Katahdin, a Native American word meaning "the greatest mountain" is the state's highest peak at 5,267 feet. Sacred to the Penobscot tribe, it is the centerpiece of 204,732-acre Baxter State Park, the nucleus of which was purchased and donated to the state by Maine ex-governor Percival Baxter in 1931. It is a campers and hikers paradise kept "forever wild," without stores, telephones, televisions, or gas stations.

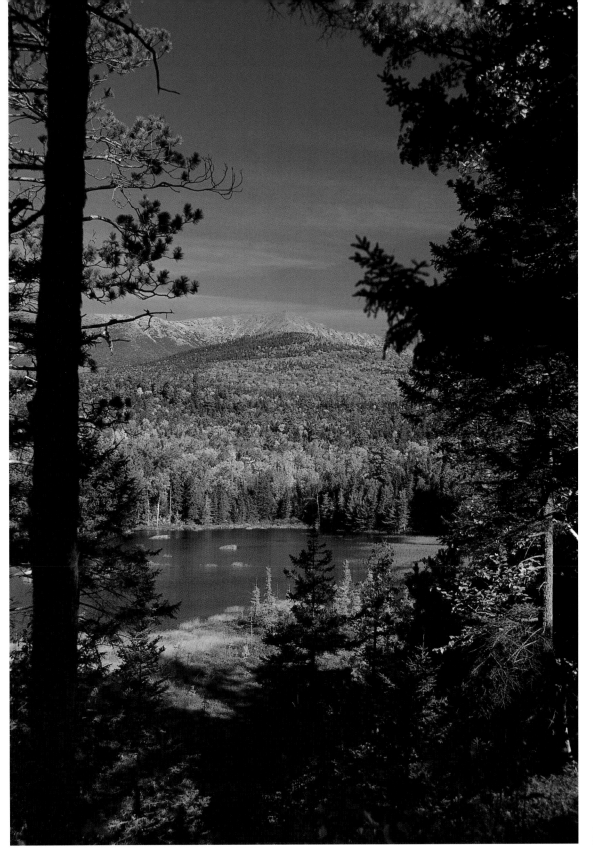

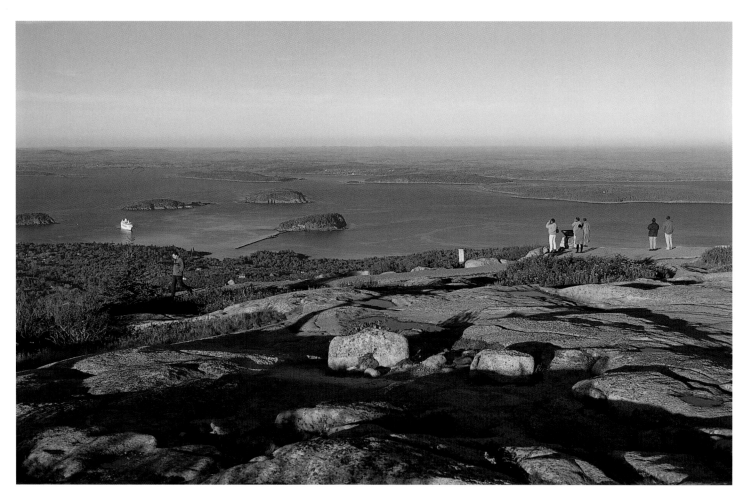

Bar Harbor, on the northeast side of Mount Desert Island, is a popular stop for cruise ships plying the waters off the east coasts of Canada and the United States. The town is also a departure point for popular whale-watching trips in the Gulf of Maine. From the summit of nearby Cadillac Mountain, the view over the town takes in the Porcupine Islands in Frenchman Bay.

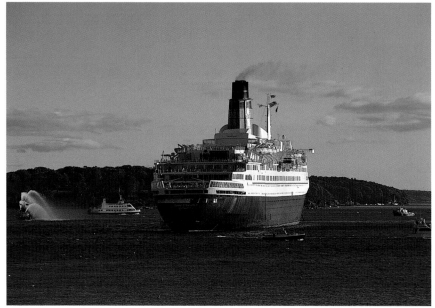

One imposing fall visitor to Maine waters is the Cunard Line's *Queen Elizabeth 2*, the last of the great transatlantic liners. Here she is being welcomed in Portland by a fireboat, a Casco Bay ferry, a Coast Guard cutter, and other vessels.

For the windjammers that remain in Maine during the winter, October is the time for "laying up" (winterizing) and repairs. Here the *Timberwind*, built in 1931 as a pilot schooner, undergoes this process in picturesque Rockport harbor. Known in the 19th century for its lime kilns (the lime was used in making cement), Rockport today hosts an active summer music colony and is also famous for one of its native sons—André the harbor seal.

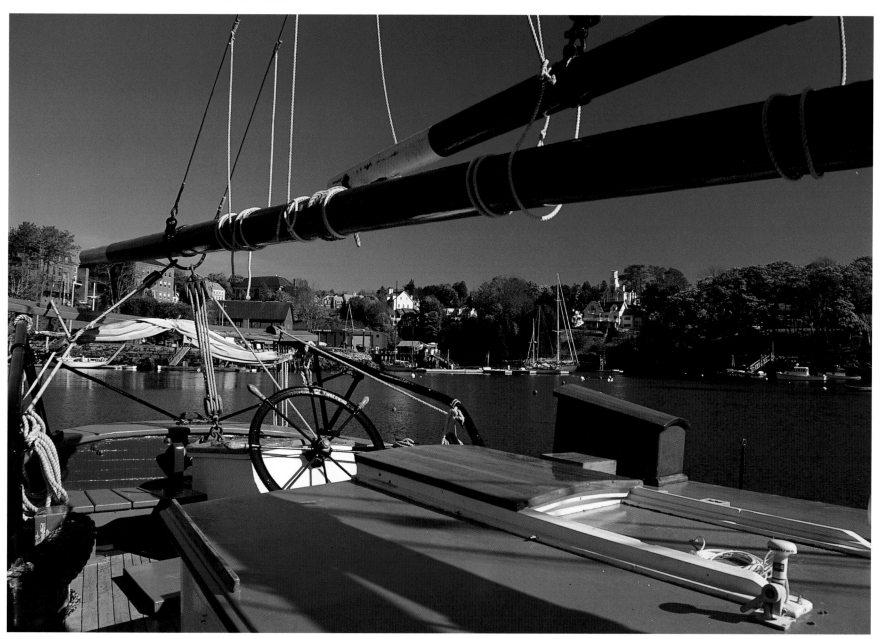

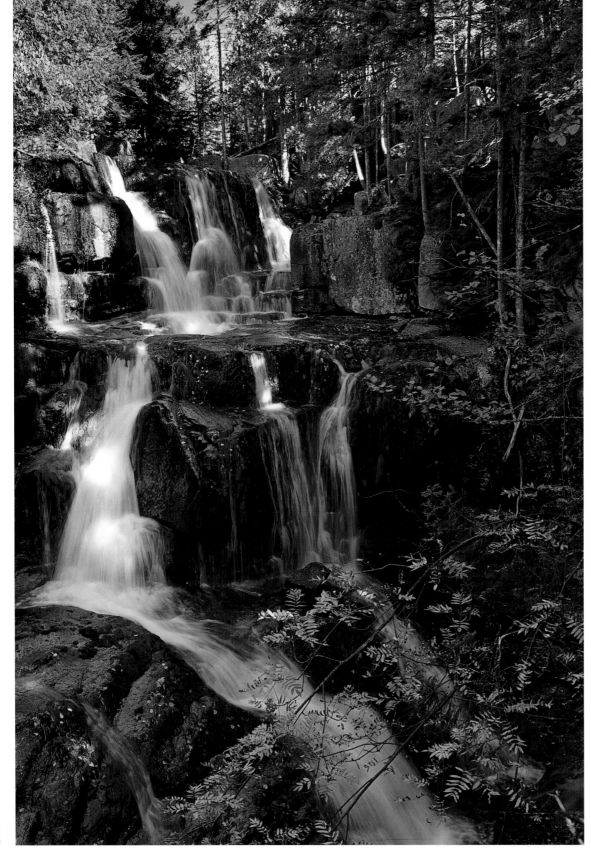

The natural beauty of Baxter State Park is legendary. One example is Katahdin Stream Falls, on the mountain's west side. The park's forty-six peaks and a hundred and seventy-five miles of trails attract thousands of visitors a year. To keep Baxter unspoiled visitors must comply with strict regulations, among which are the prohibition of radios, cell phones, and pets—as well as a size limit on the vehicles allowed on the narrow dirt road that encircles the park.

Century-old maple trees arch over the Class of 1916 Walk along Bowdoin College's central quadrangle. Bowdoin, Bates, and Colby are Maine's best-known liberal-arts colleges.

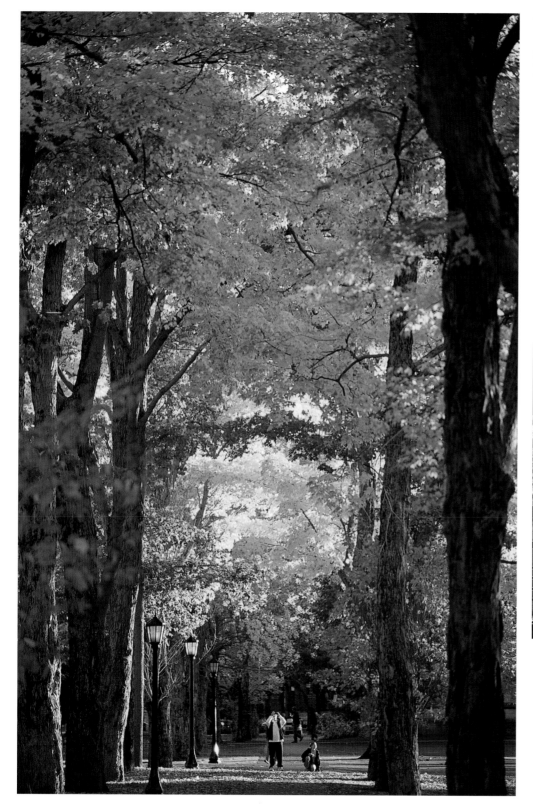

In Orono, the University of Maine's marching band gives rousing support to the school's football team, nicknamed the Black Bears. UM, as it now likes to be known, has excellent academic programs, and its championship hockey, basketball, and baseball teams delight sellout crowds.

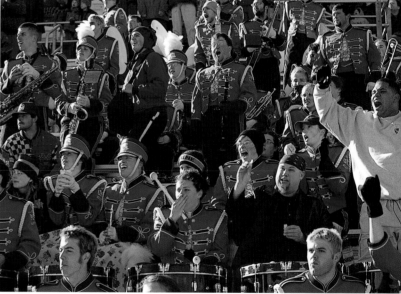

All of Maine's beauty is by no means in the mountains. The state's largest salt marsh, in Scarborough, is just a short drive from Portland. Its more than three thousand acres offer excellent kayaking and canoeing, as well as Maine Audubon–sponsored birding and nature walks.

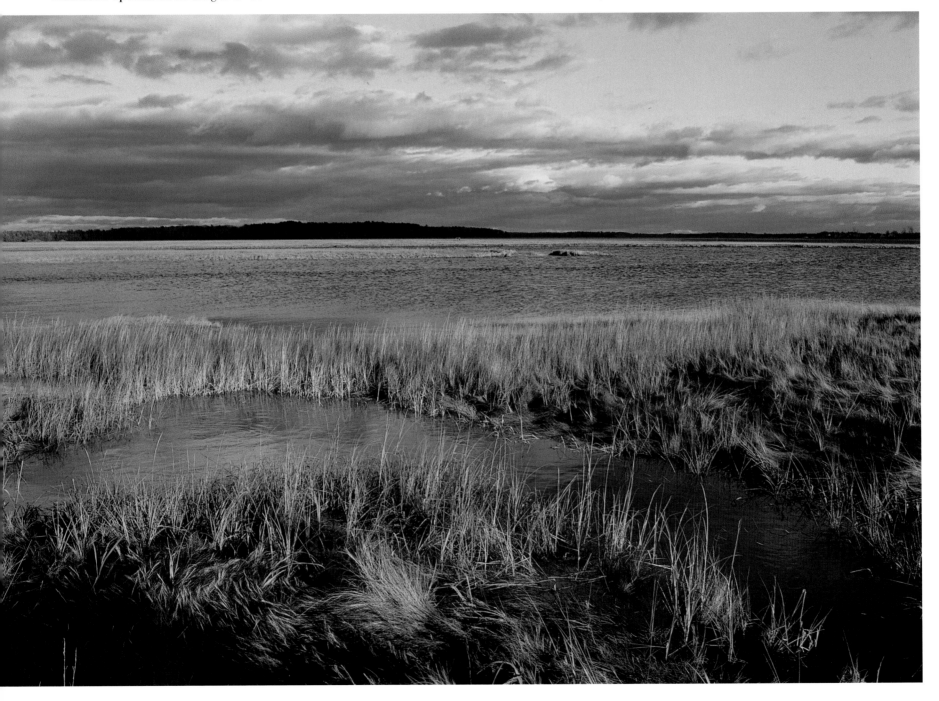

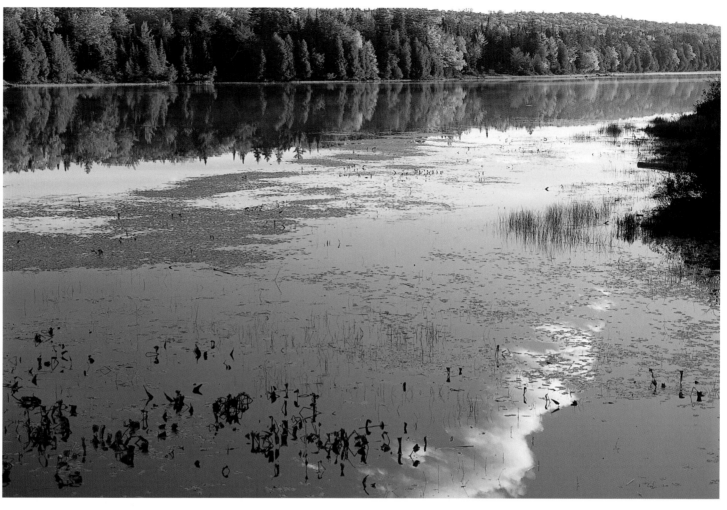

The lakes and rivers of northern Maine offer endless views of unexpected natural beauty. Spectacle Pond, south of Greenville and Moosehead Lake, multiplies the magnificence of peak fall colors.

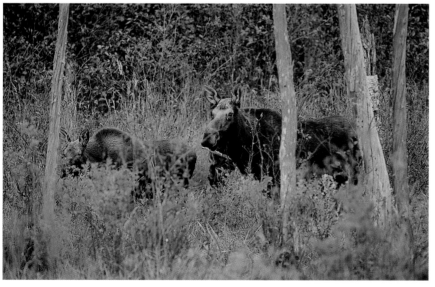

Though sometimes laughed at, the moose—Maine's state animal—is an awesome sight. A mature bull stands over eight feet tall, can easily weigh half a ton, and carries antlers over six feet across. Such a mass is to be avoided at all costs when driving a car. Nearsighted but sharp of hearing, moose are the most valued trophy to have seen and photographed on a visit to Maine.

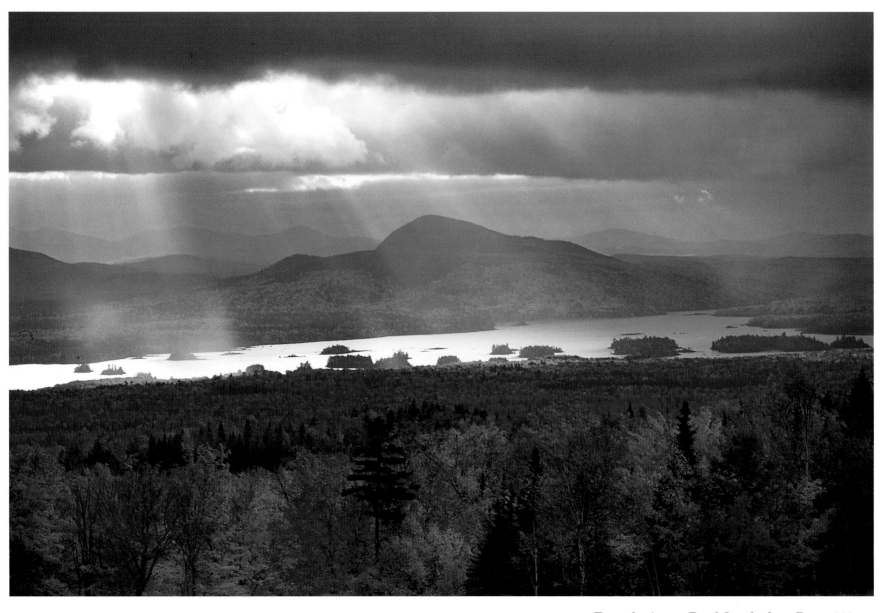

From the Attean Pond Overlook on Route 201, westward views into Canada change constantly with the weather and the seasons. This road runs from the midcoast towns of Brunswick and Topsham through Augusta, Skowhegan, Bingham, and Jackman, where it crosses the Canadian border and continues to Quebec City. In all, the drive takes some six hours. The stretch between Bingham and Jackman, which includes the overlook, well deserves its designation as one of the four National Scenic Byways in Maine.

North of Bingham, Route 201 skirts Wyman Lake, formed by the Wyman hydroelectric dam across the Kennebec River. Tucked away here and there along the shore are privately owned "camps," a feature common along the lakes, rivers, and streams of the state. Rustic cottages have been important to Maine families for generations as retreats from the daily grind.

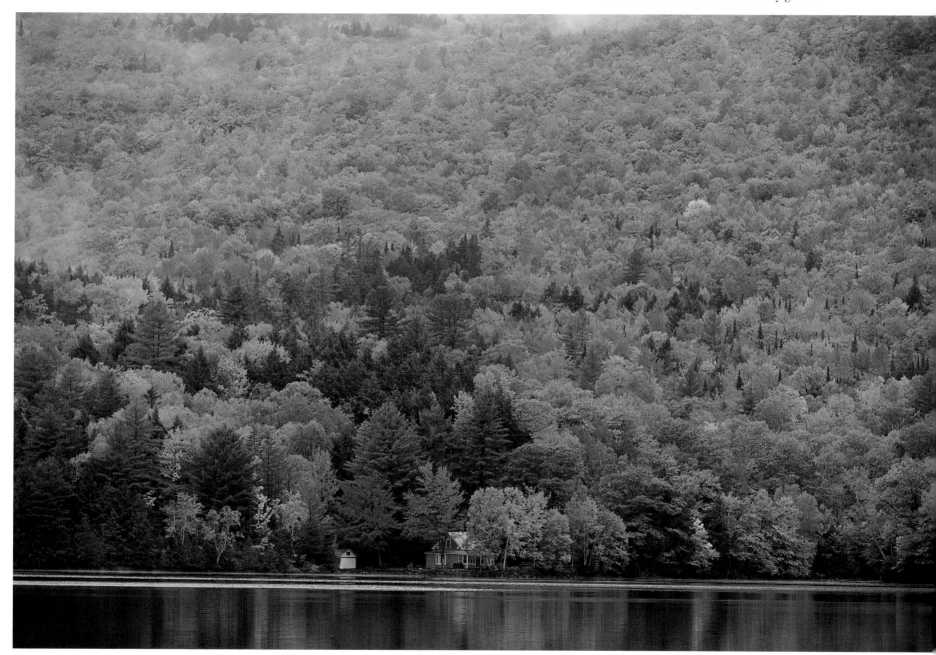

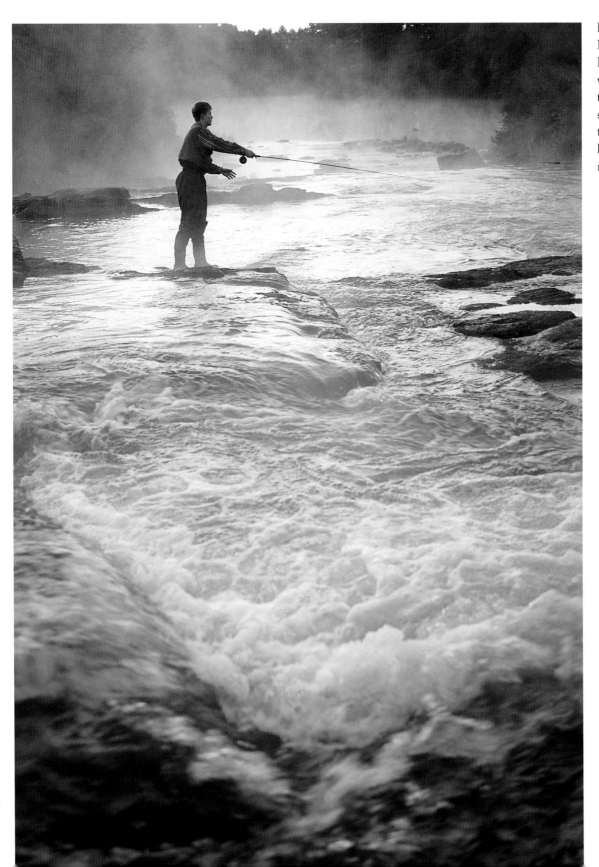

Freshwater fly-fishing enthusiasts consider Maine's waters to be some of the best in the East. Encouraged by such outfitters as L. L. Bean, which gives fly-fishing lessons from spring through fall, and by fishing lodges across the state, sportsmen come from everywhere to try their luck on native landlocked salmon and brook trout in more than thirty-two thousand miles of rivers and streams.

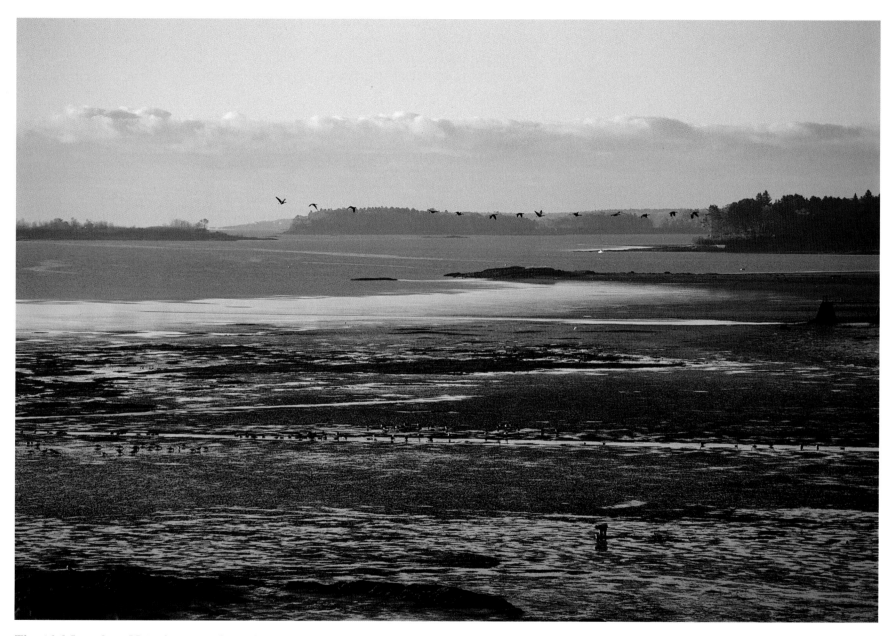

The tidal flats along Maine's coast, where the vertical change in water level can be anywhere from eight to twenty-seven feet in each six-hour cycle, are the source of a vast variety of commercially valuable marine life. In Broad Cove on Casco Bay, a clam digger is almost lost among the highlights of the flats and the Canada geese. Other commonly harvested inshore species are sea cucumbers, mussels, and bloodworms, which are used for bait by saltwater anglers.

On the long Dead River run, rafters and kayakers alike can experience Class III to Class V rapids. The trips are coordinated with the release of water from Central Maine Power's hydroelectric dams upriver.

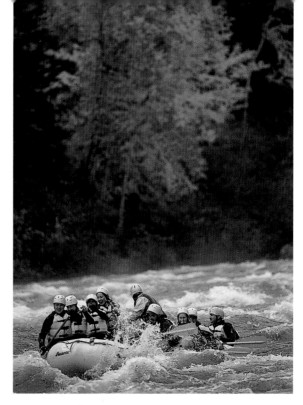

Whitewater rafting and kayaking have brought new economic life to The Forks, a hamlet at the confluence of the Dead and Kennebec Rivers. Each year, from April through October, a large number of outfitters guide nearly a hundred thousand thrill-seekers on rides of twelve to sixteen miles.

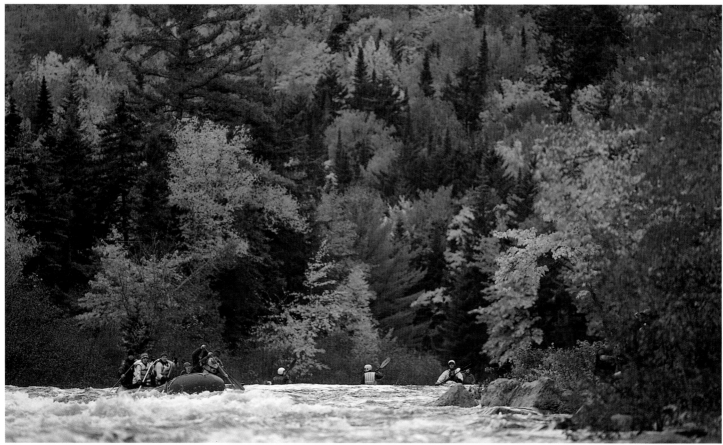

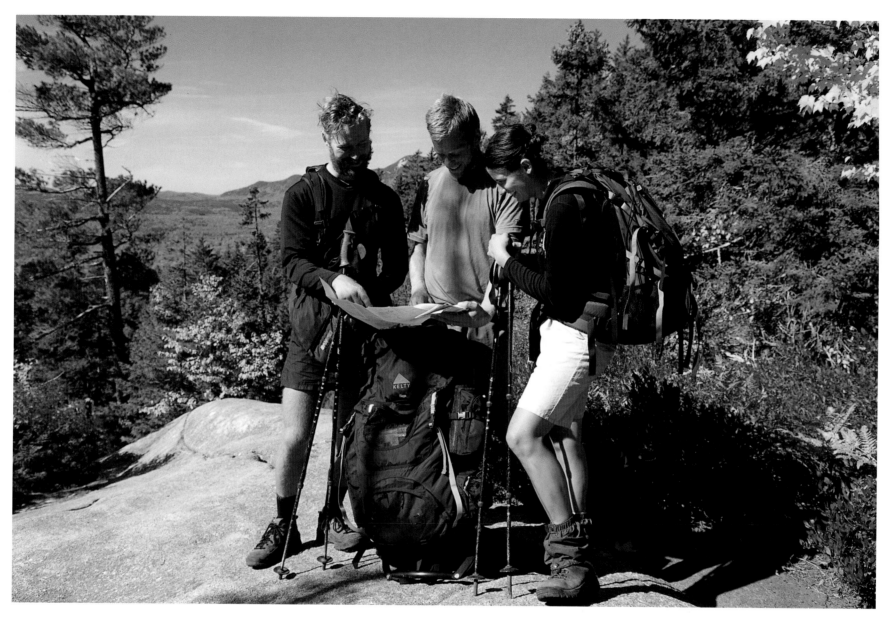

Happy indeed are these Appalachian Trail through-hikers as they check their map on the Hunt Trail, just a few miles shy of Katahdin's summit. When they reach the top, they will have completed their 2,158-mile hike from Georgia's Springer Mountain.

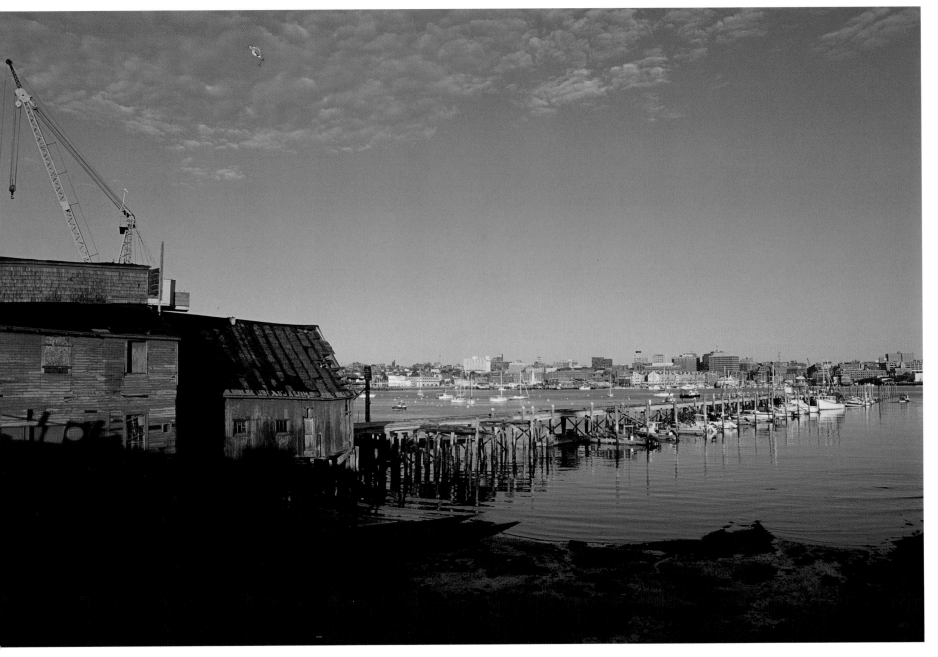

The waterfront of South Portland is much quieter than its counterpart in downtown Portland, just a mile across the harbor. This scene was markedly different during World War II, when South Portland was home to a flourishing ship-building industry. It employed more than thirty thousand workers, who built 236 Liberty Ships to carry cargo for the Allied war effort.

One of the busiest sections of the Portland water-front is adjacent to the Maine Fish Exchange, where more than two hundred million pounds of fresh seafood is unloaded annually. Here an optimistic angler hopes that level of success will rub off on him as the morning fog lifts over the harbor. First used by merchant vessels in 1632, Portland now is New England's second largest seaport, with expectations of doubling its volume in ten years.

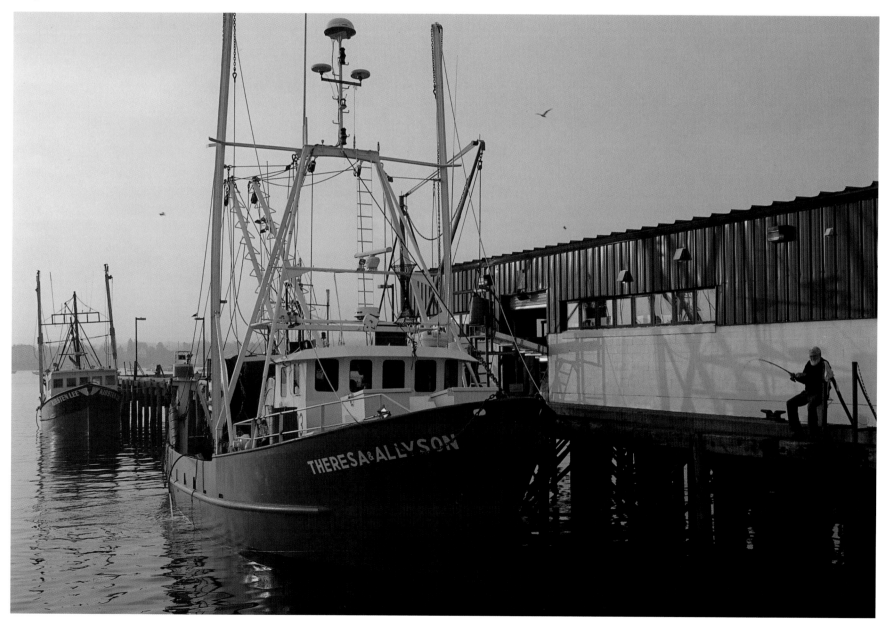

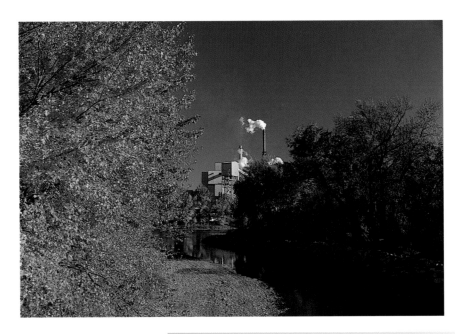

In the middle of Maine's Western Lakes and Mountains Region is the papermaking town of Rumford. This hardworking community was the birthplace of Maine Governor, U.S. Senator, and Secretary of State Edward S. Muskie, who helped clean up the Androscoggin and countless other rivers as the author of the Clean Water Act.

On the lee side of the Camden Hills, as in many other places statewide, fallow fields have been converted to Christmas tree farms. This six-million-dollar-a-year industry sells trees across New England and around the world.

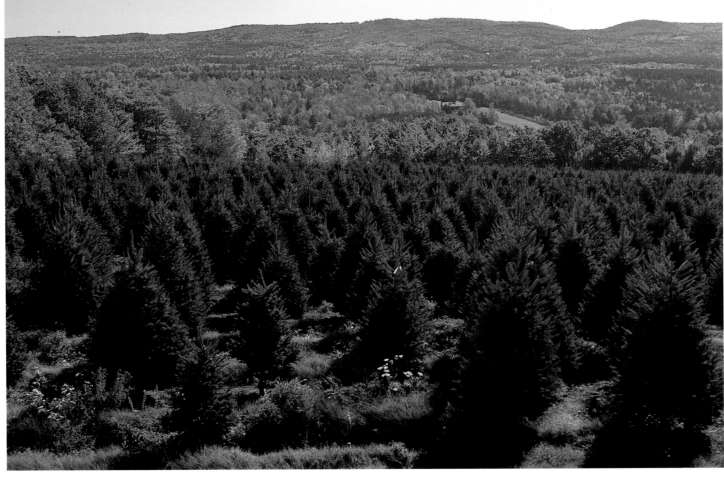

One of the most spectacular of Maine's two hundred and fifty golf courses is part of the huge Sugarloaf resort. Set in the glorious Carrabassett Valley, its tees, greens, and fairways offer vistas like this tenth-hole view of the fall foliage in the Crocker Cirque in the Bigelow Range.

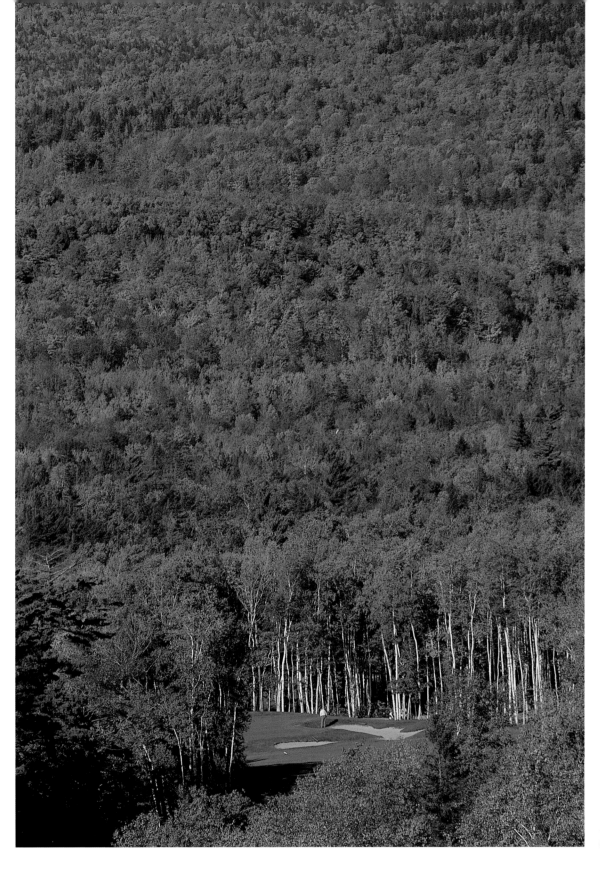

The stillness of dawn glazes the waters of Cape Porpoise Harbor, near Kennebunkport. York County's proximity to Portland; Portsmouth, New Hampshire; and even Boston, Massachusetts (one-and-a-half hours away) is drawing more and more people to the area.

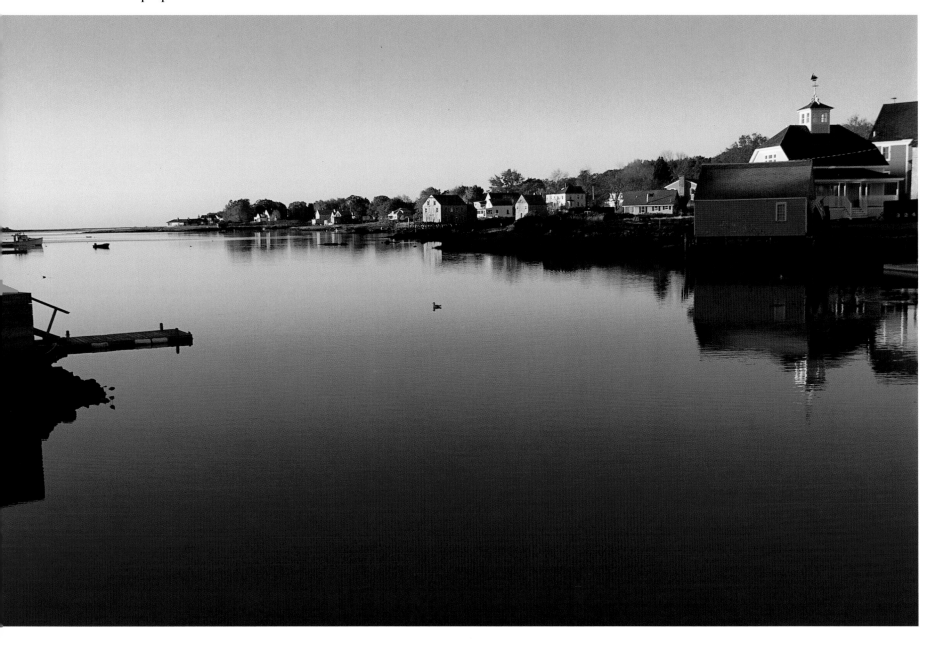

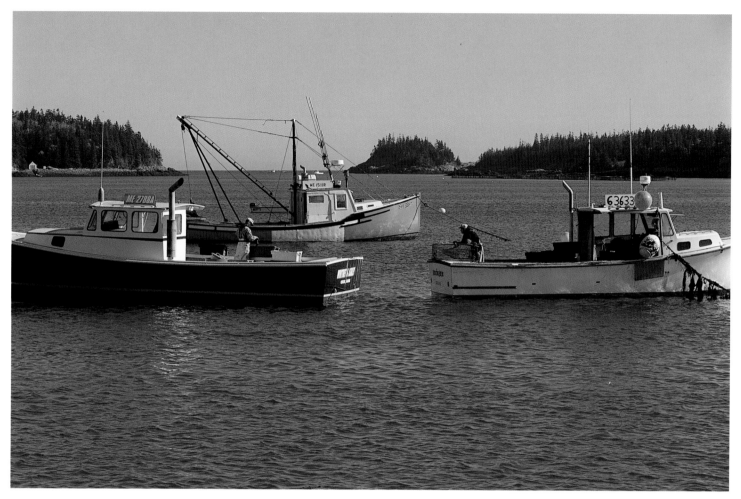

In Cutler Harbor, way down east, two fishermen
band the claws of their day's catch. Most lobster-
men head to sea at dawn's first light and check
each trap every few days.

An affinity for the sea runs deep in Maine fami-
lies, and the sons and daughters of lobstermen
often take up this challenging and dangerous
trade. Some coastal Mainers set just a few traps
and haul them by hand to supplement their in-
comes or put fresh seafood on the table. Others
fish commercially from large boats, using pow-
ered haulers to lift the gear from depths of 300
feet or more.

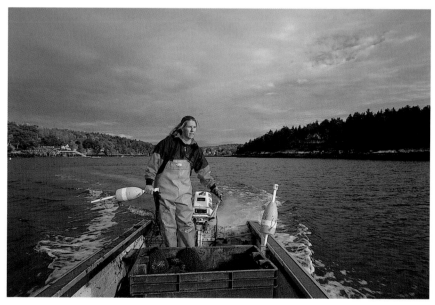

Canada geese by the hundreds congregate along the shores of Casco Bay from dusk to dawn between October and January. During the day, they fly inland to glean what they can from harvested fields of grain and corn.

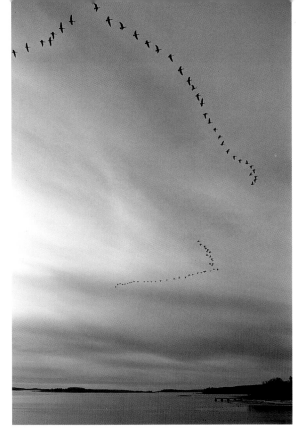

A certain harbinger of the coming winter is an early autumn snow, which generally brings to an untimely end the riotous color of the fall woods.

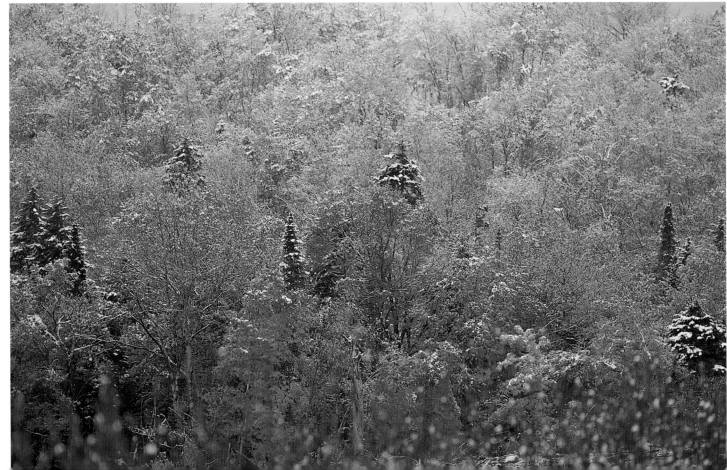

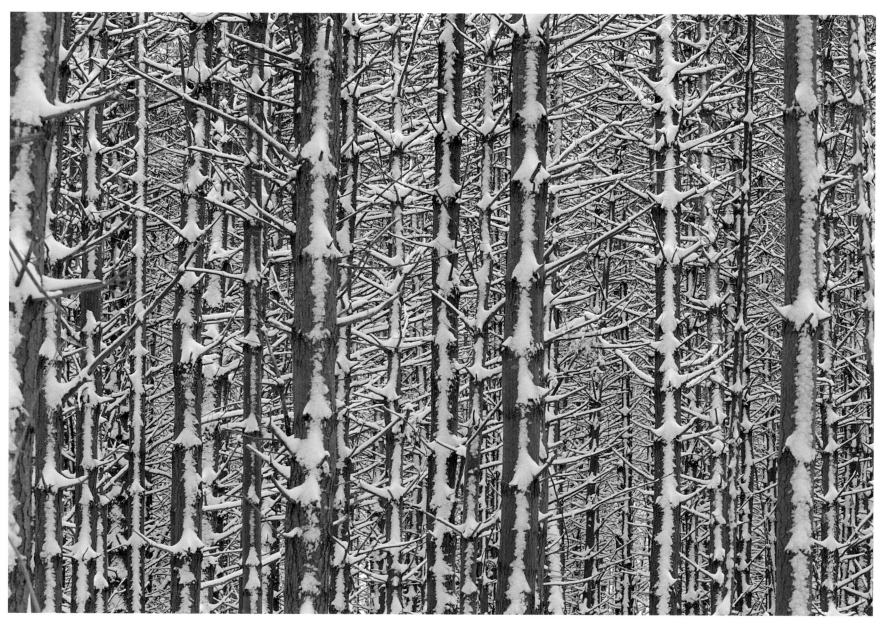

A wet snow patterns a white-pine forest in
Wolfe's Neck State Park, outside Freeport.

When the tourist season ends and the windjammers are put into wet storage until spring, it used to be that most major economic activity in coastal towns like Camden quieted as well. But thanks to the recent influx of "clean" industries such as MBNA—a credit-card bank—communities from Portland to Belfast are enjoying new, year-round economic prosperity.

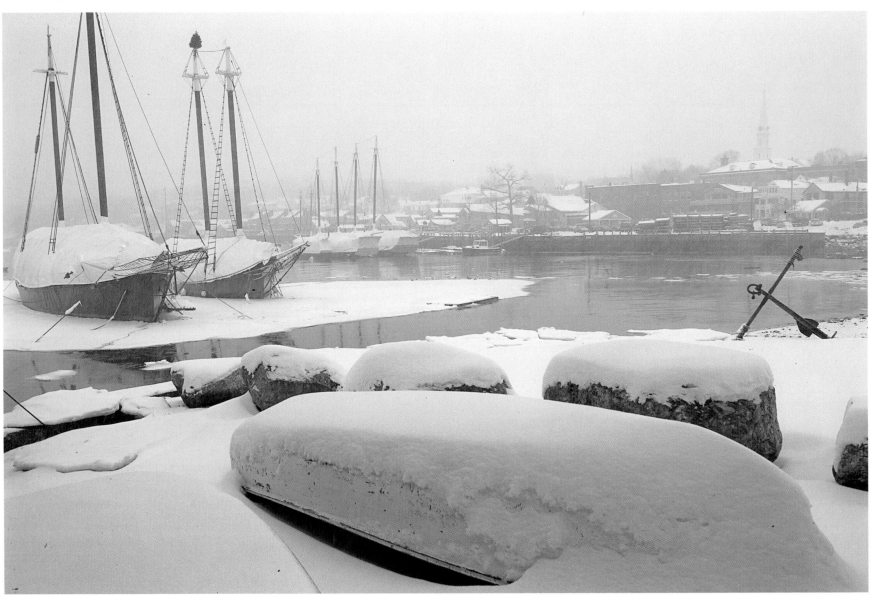

Sea smoke, which appears when the temperature of the air is much colder than that of the water, lends a mysterious effect to the surface of Portland Harbor as a Casco Bay ferry brings early commuters ashore. These vessels serve the six islands that have year-round inhabitants.

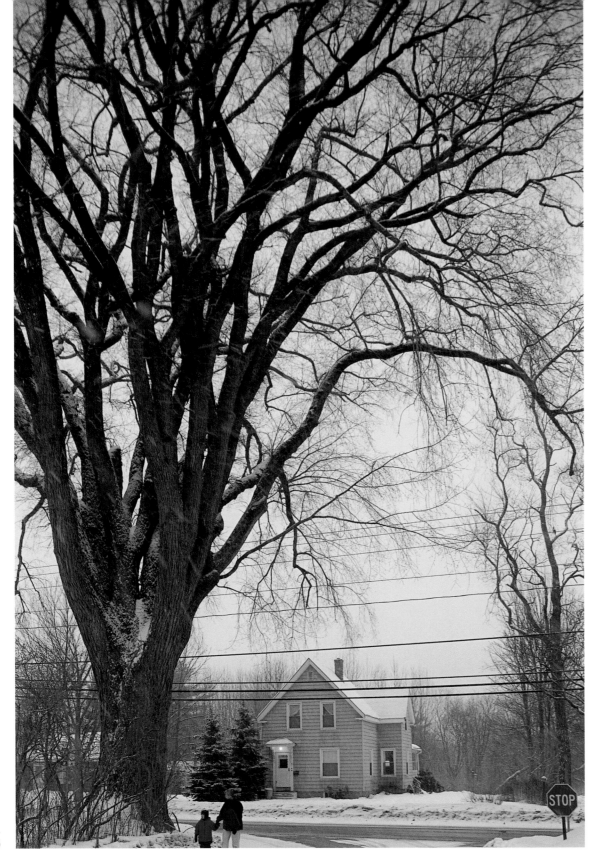

"Herbie," Maine's largest elm tree, was planted during the Revolutionary War. It stands 110 feet high, arching over Route 88 in Yarmouth. Before the disastrous Dutch elm disease hit in the 1950s, the town boasted a thousand elms. Today there are fewer than twenty, all lovingly nurtured and monitored for any sign of the disease.

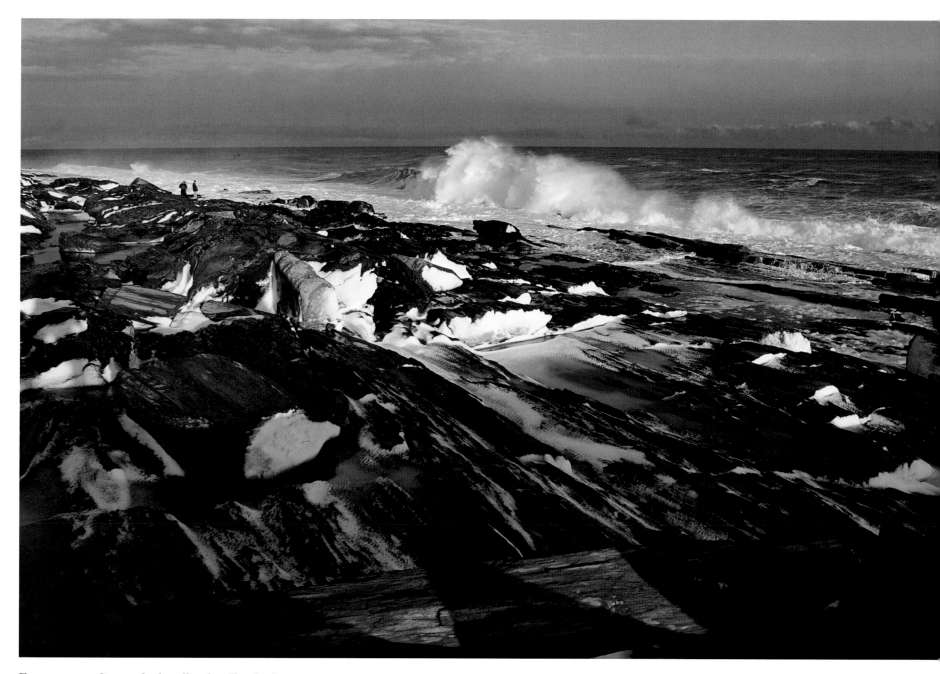

Frozen spume litters the headland at Two Lights
State Park in Cape Elizabeth, south of the en-
trance to Portland Harbor. Literally taking their
lives in their hands, several young people edge
close to the crashing breakers, remnants of a win-
ter storm.

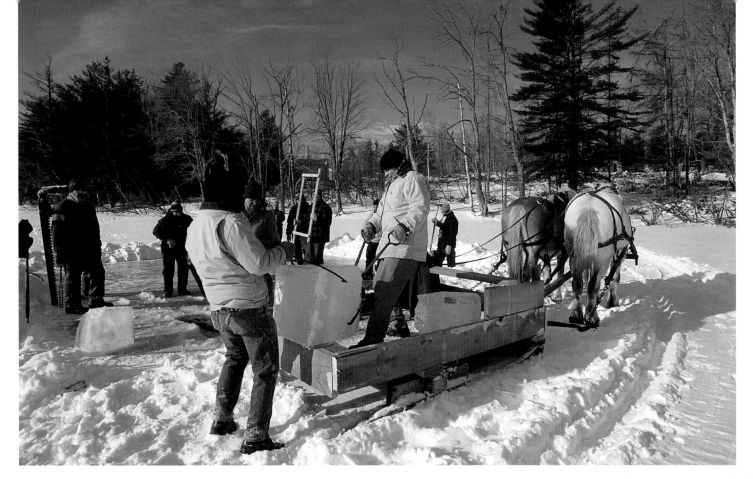

The Norlands Living History Center in the western Maine town of Livermore educates visitors in the ways of 19th-century farm life. Cutting blocks of ice to provide summertime refrigeration in the farm's kitchen, visiting students from the University of Pennsylvania learn firsthand the rigors of rural living.

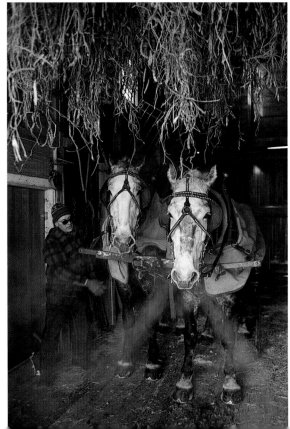

Sturdy draft horses are unharnessed in the Norlands barn after hauling the blocks by sled to the icehouse, where they were packed in sawdust. In the 19th century, harvesting ice was big business in Maine, and clipper ships carried it as far as Africa and India. In 1880 alone, 640,000 tons were shipped by operations on the Kennebec River.

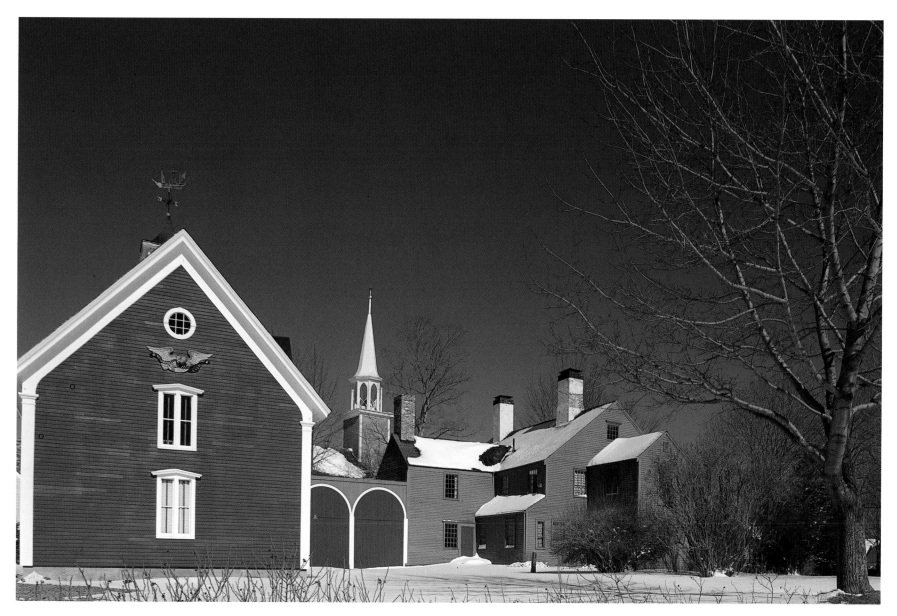

The self-described "Prettiest Village in Maine," Wiscasset is a beautifully unspoiled town that steps down the west bank of the Sheepscot River to the water. Although it lies twelve miles from the open ocean, Wiscasset was a major 19th-century shipbuilding and trading center, hence the number of unusually fine merchants' and sea captains' homes here.

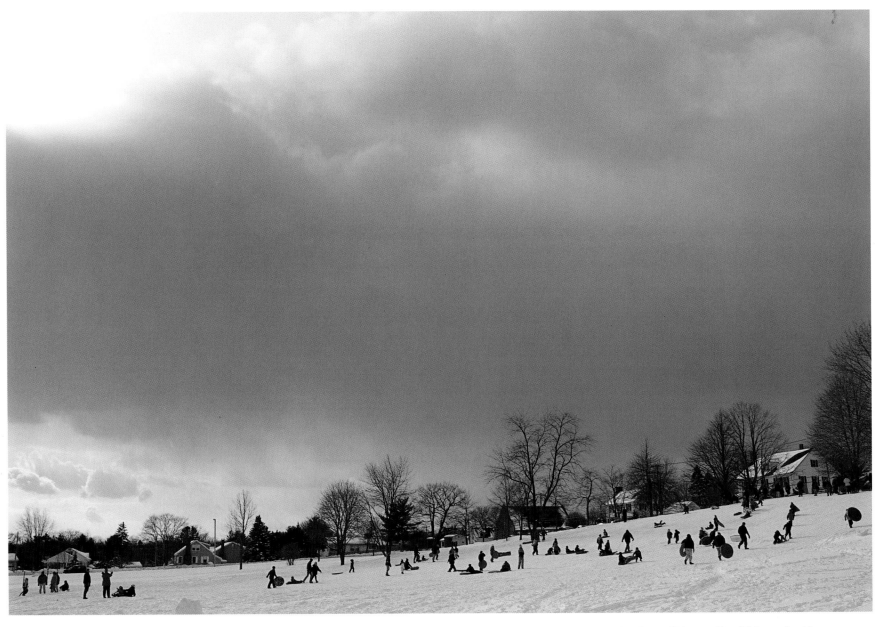

Portland is a "Forest City" blessed with many parks, all of which add to its excellent quality of life. Forty-eight-acre Payson Park, across Back Cove from downtown, offers baseball diamonds, tennis courts, and—in the winter—one of the city's busiest coasting hills. Members of Portland's growing immigrant community, among them Laotians, Vietnamese, and Somalis, are some of the most enthusiastic sledders and snowboarders.

Maine has become the premier sledding destination in the eastern United States. About a hundred thousand machines are registered in Maine, and many more come into the state by trailer and trail, generating close to $300 million dollars of revenue.

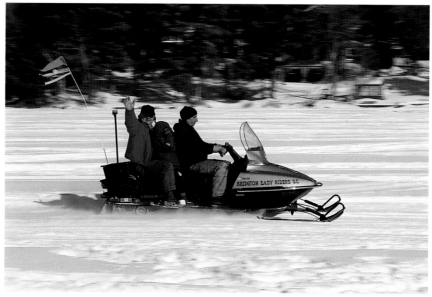

In Fort Kent, on the Canadian border, the local snowmobile club's grooming machine stops to let a string of sleds from New Jersey pass. Some twelve thousand miles of snowmobile trails crisscross Maine and connect sledders to neighboring states and Canada.

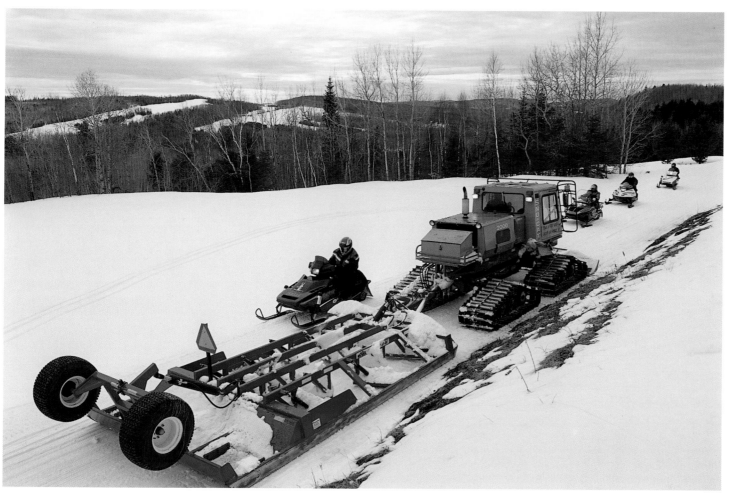

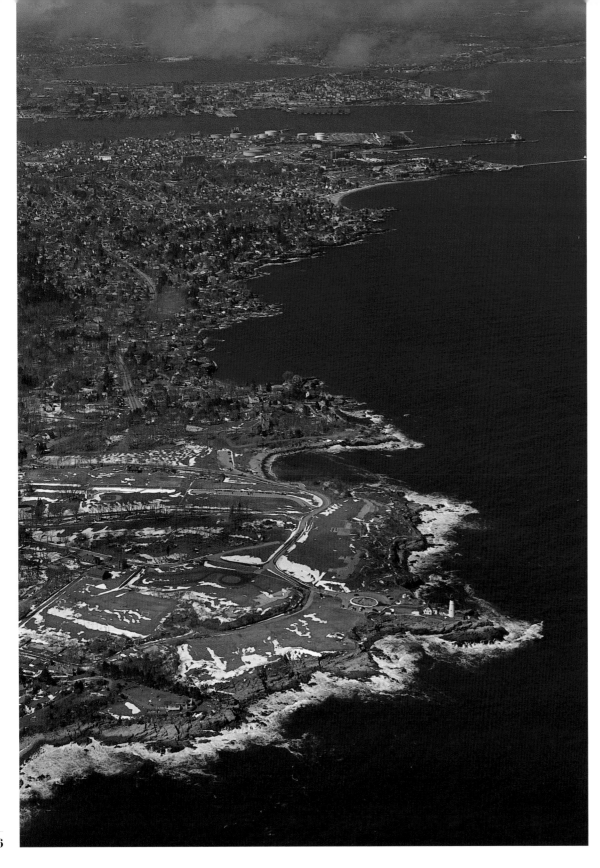

The south side of the ship channel leading to Portland Harbor (top left) begins at Portland Head Light. Commissioned by President George Washington and built in 1791, it is Maine's oldest lighthouse and—because it stands so near a major population center—the most visited. Nearly one quarter of the state's population lives within the greater-Portland area, but because this is Maine, there is little sense of crowding. A short walk or a few minutes' drive will bring you to the sea or the countryside.

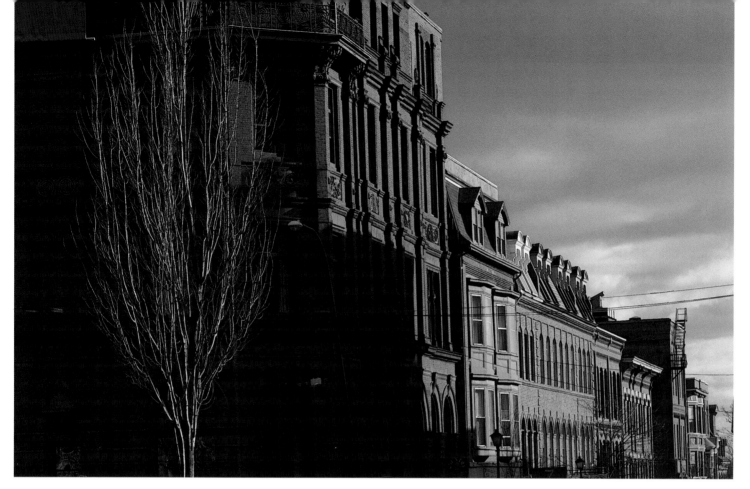

The brick façades of the Victorian buildings on Portland's Exchange Street are typical of much of the downtown architecture. Few structures predate 1866 because of a Fourth of July fire that destroyed the city's center that year.

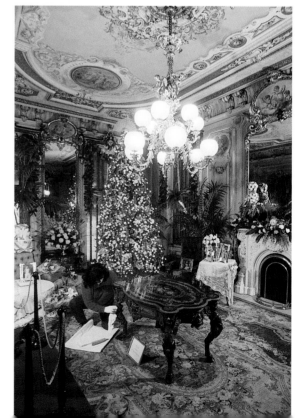

Victoria Mansion, an elegant early Victorian Portland home survived the fire with much of its original furniture intact. Built by ninety-three craftsmen in the 1850s, the mansion is spectacularly decorated at Christmas.

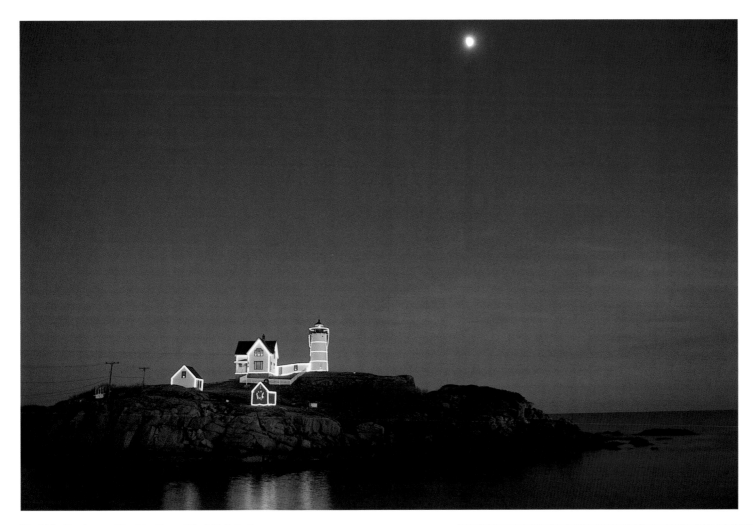

Nubble Light on York's Cape Neddick is be-
decked for the holiday season. Before automa-
tion, lighthouse keepers would access the light
via a short aerial tram at high tide or in stormy
weather.

When the visitors "from away" have departed,
a number of the businesses along well-traveled
Route 1 close their doors until spring. Similarly,
tourist-oriented towns like Boothbay Harbor
"roll up the rug."

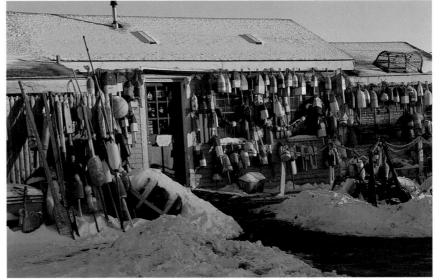

98

The orientation of the stark peninsulas in mid-coast Maine clearly indicate the direction (northeast by southwest) of the glacial action that formed them more than eleven thousand years ago. Orr's Island (foreground) and Bailey Island (top) are linked to each other and to the mainland by bridges. The span that ties the two islands together is unique, for its granite-cribwork construction permits the tide to flow through.

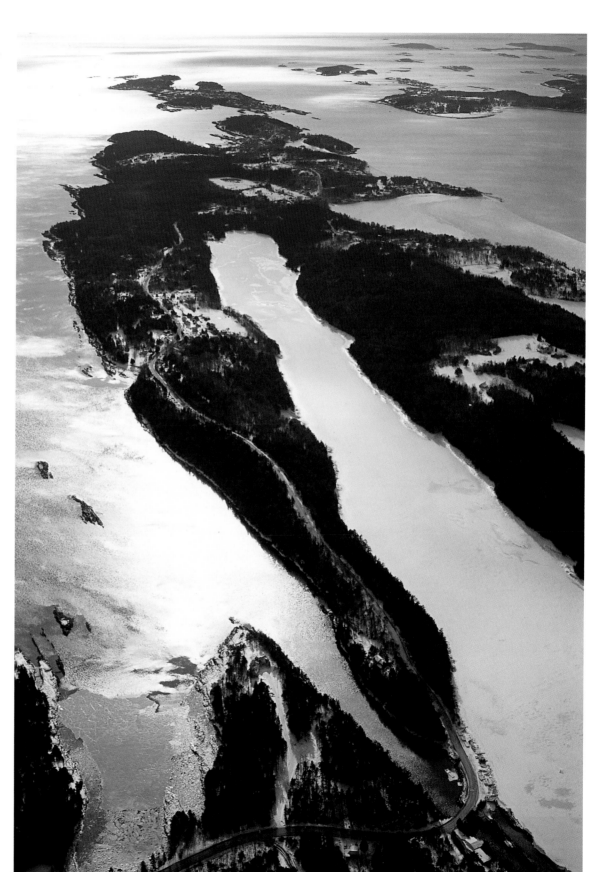

Farmers in agricultural states like Maine do not have the luxury of closing down their operations in winter. But at the end of the day, they retreat to their cozy homes, many of which have been in the family for generations. Not surprisingly, some 75 percent of Maine houses use wood as either a supplemental or primary source of heat.

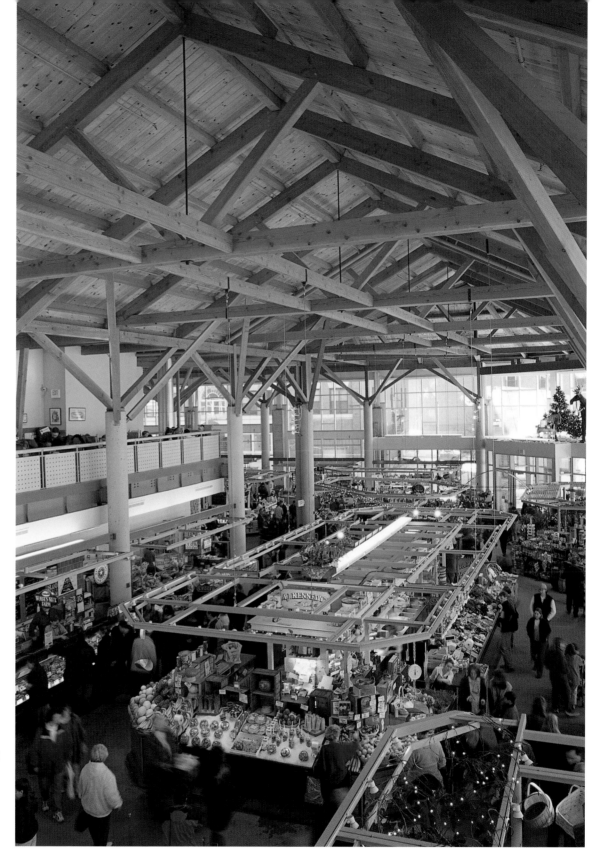

The Portland Public Market, opened in 1998, provides local Mainers with access to the fresh foods and produce long offered near this spot. The city's first public market—located just a block away—was removed to make way for a Civil War memorial and Monument Square. Today the new market is one of a number of renovated facilities in Portland, where more money per capita is spent on dining out than in any other American city except New York and San Francisco.

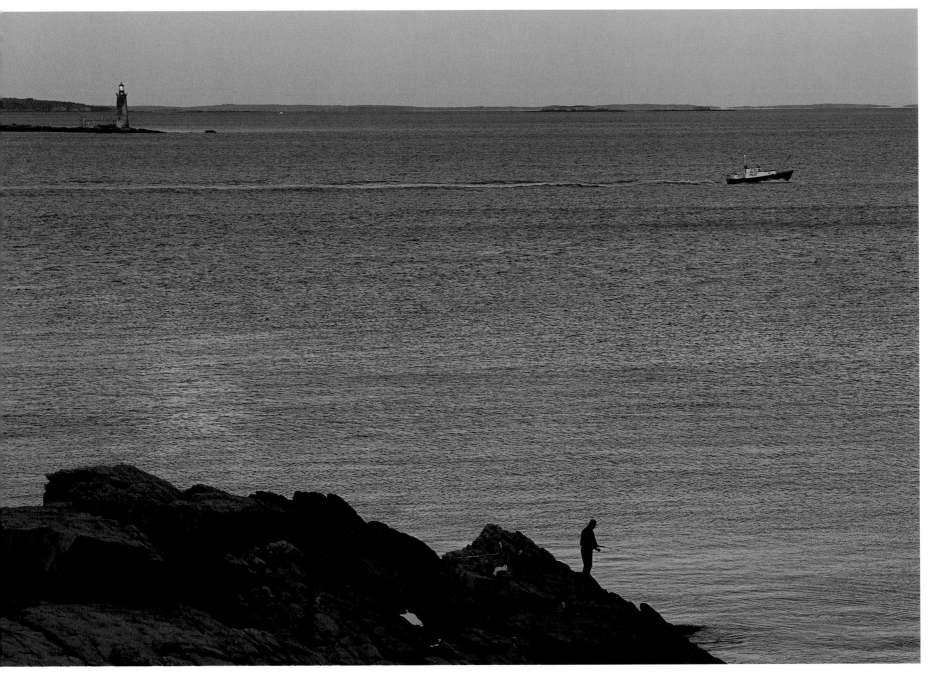

A solitary fisherman braves the cold at the entrance to the Portland ship channel, across from the stark and lonely light on Ram Island Ledge. This lighthouse, built in 1905 of 699 four-ton granite blocks from Vinalhaven, now uses solar power to illuminate its white light, which shines from a height of seventy-seven feet above the surf.

Winters are long and the snow piles high in northern Aroostook County. The region's potato-storage barns are built deep into the landscape to ensure cool, constant temperatures. Nearly two billion pounds of Maine potatoes are harvested each year; most of them go into French fries and potato chips.

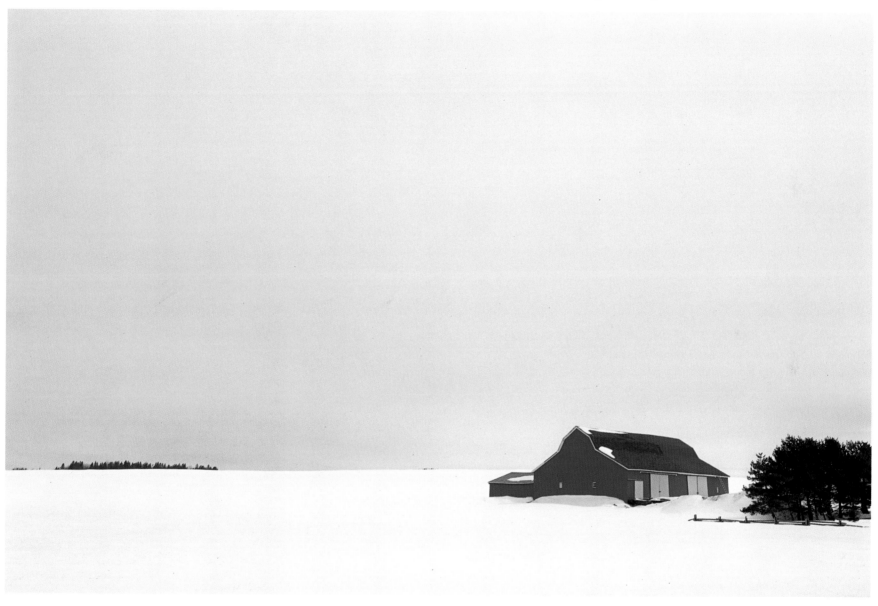

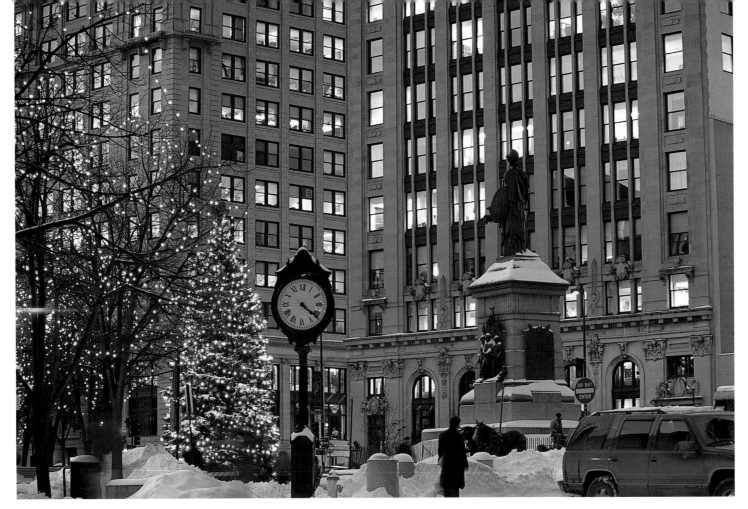

Monument Square, in the heart of Portland's business district, is the site of many public events throughout the year, from the lighting of the municipal Christmas tree and the Chinese fireworks of New Year's, to summer farmers' markets and musical events that bring Irish singers and Bahamian steel bands to the city. The monument itself commemorates the Mainers who fought in the Civil War.

Merrill Auditorium, in Portland's City Hall, is the home of the Portland Symphony Orchestra as well as the site of everything from acrobatics to operatics. In December, the auditorium traditionally hosts *The Magic of Christmas*, featuring the orchestra, guest musical celebrities, and a 150-voice chorus assembled from local singing groups just for the occasion.

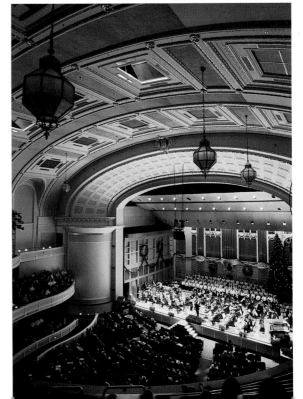

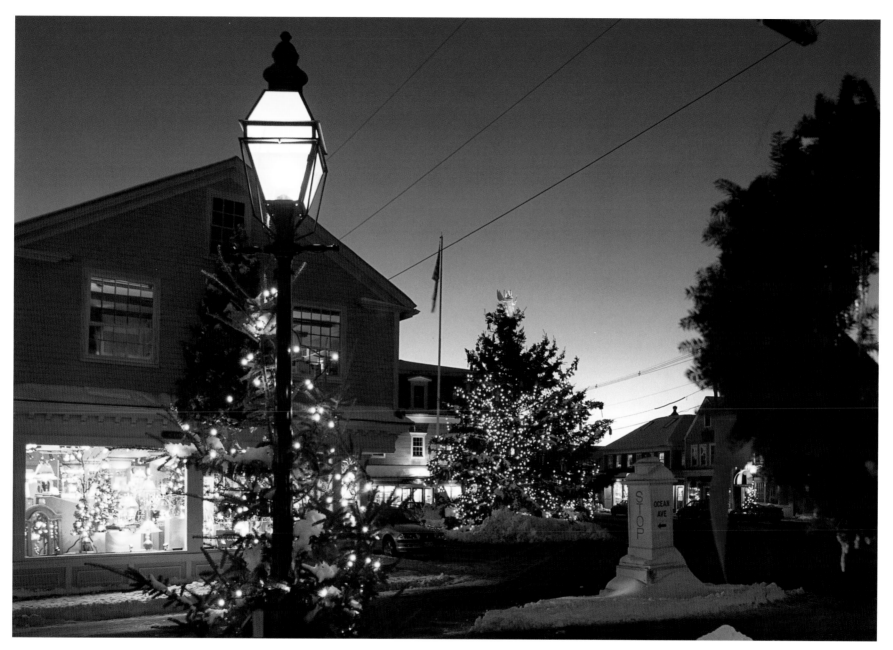

Towns throughout Maine have taken to celebrating special winter-holiday weekends with caroling, hayrides, tuba concerts, and—above all—shopping. Among the many examples: Kennebunkport (above) has its "Christmas Prelude" in Dock Square; Freeport hosts "Sparkle Weekend"; and Camden sponsors "Christmas by the Sea."

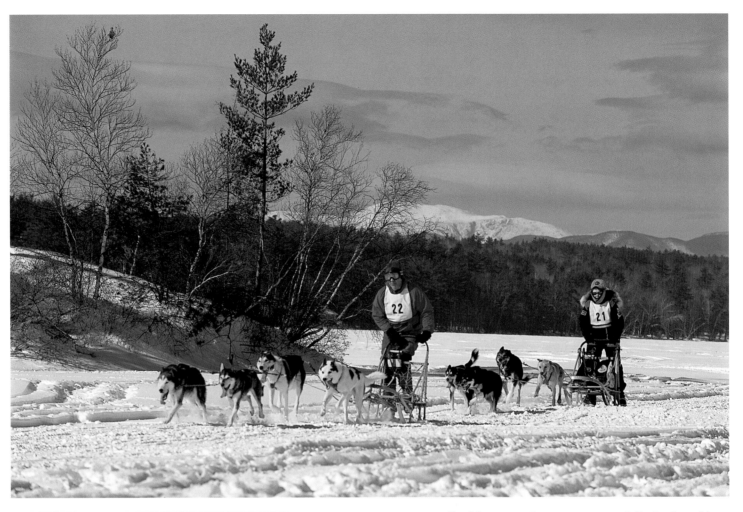

In this state, winter sports aren't limited to skiing, skating, and sledding. Iceboating, ice fishing, snowshoeing, and tobogganing are other favorite seasonal pastimes. And here on frozen Highland Lake in Bridgton, the Mushers Bowl competition attracts a hundred and twenty-five dog-sled teams.

Rapport between each competitor and his or her dogs is vital. By gaining their respect and loyalty, a good driver can control a team that is physically much stronger and capable of overwhelming any human.

Ice fishing is enjoyed across the state. As soon as the ice is about six inches thick, shacks begin to appear on Maine's lakes and ponds. Landlocked salmon and trout are among the most popular species caught, but bass, perch, and pickerel are common, too. Fishing shacks vary in sophistication, but the fanciest have battery-powered televisions and kerosene heaters. Of course, there is never a problem keeping the beer cold.

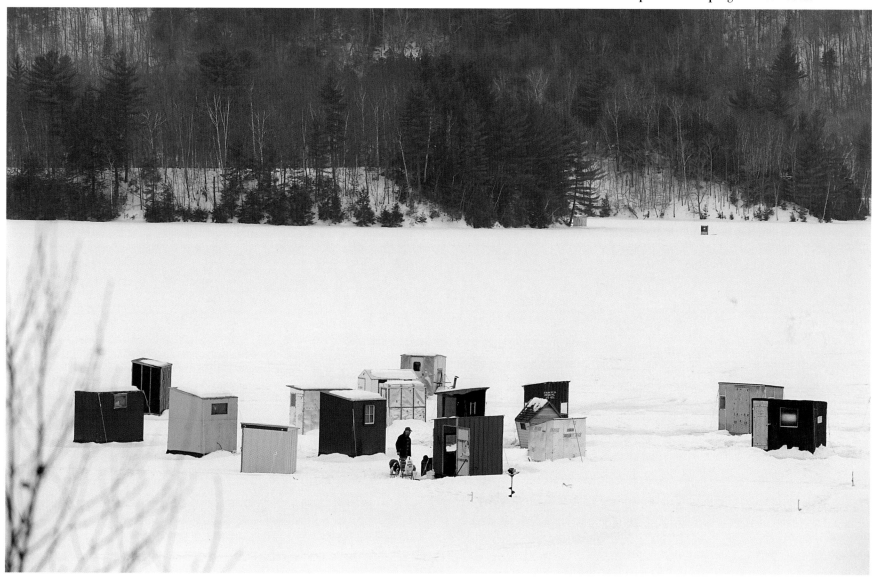

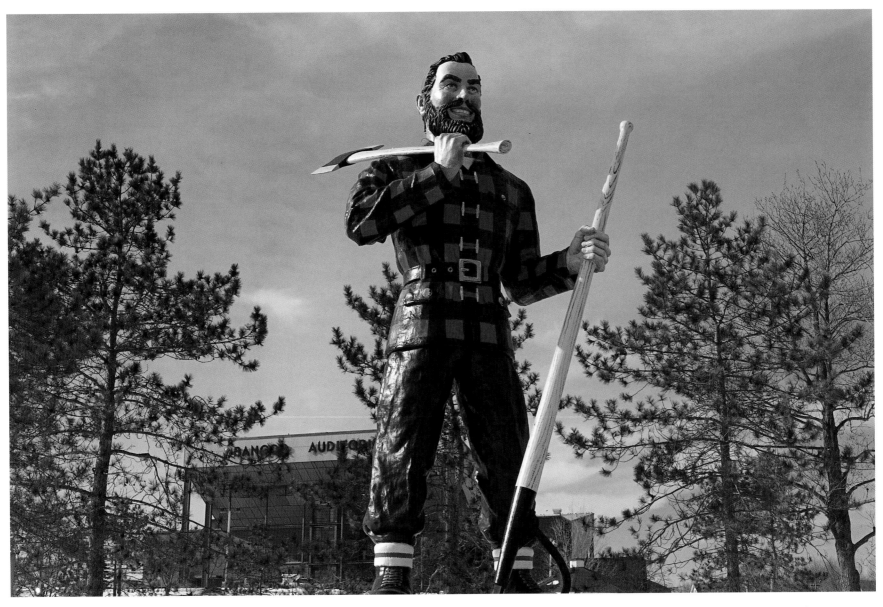

A giant mythological figure of the 19th-century North Woods, Paul Bunyan is celebrated in a thirty-one-foot-tall statue of the great lumberjack. It stands in front of the Bangor Civic Center as a reminder of the huge debt all Mainers owe the forests and the men who work in them.

Making syrup is an inexact science, where practice and experience pay real dividends. It takes roughly forty gallons of sap to produce one gallon of pure Maine gold.

Mainers are an independent lot. Little pleases them more than earning a good living or, at least, supplementing their livelihoods by dint of their own hands and the bounty of the land. Digging soft-shell clams, picking crabmeat, and making maple sugar and Christmas wreaths are some of the endeavors that prove honest, hard work is worthwhile.

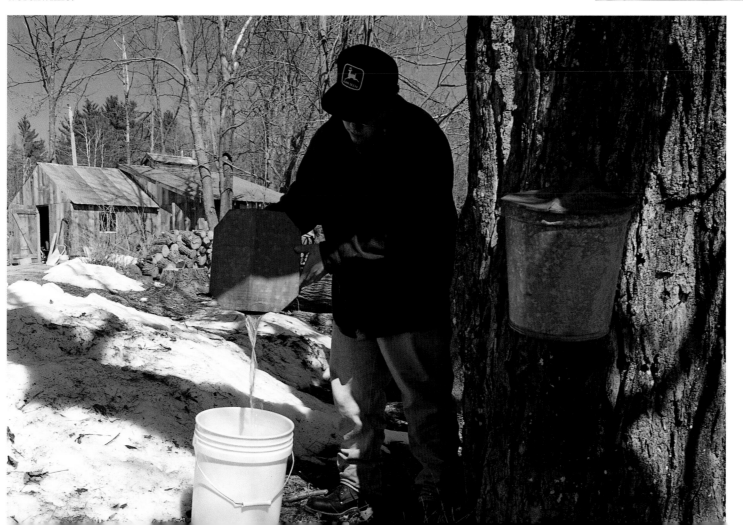

Skiing is one of the major winter industries in Maine, where there are some forty ski areas in operation. In the mountainous western part of the state, Sunday River in Bethel offers a huge variety of lifts, trails, and glades within a network that covers six separate mountains. To extend the ski season when nature doesn't cooperate, the resort has invested in an arsenal of snowmaking equipment that includes more than a thousand snow guns.

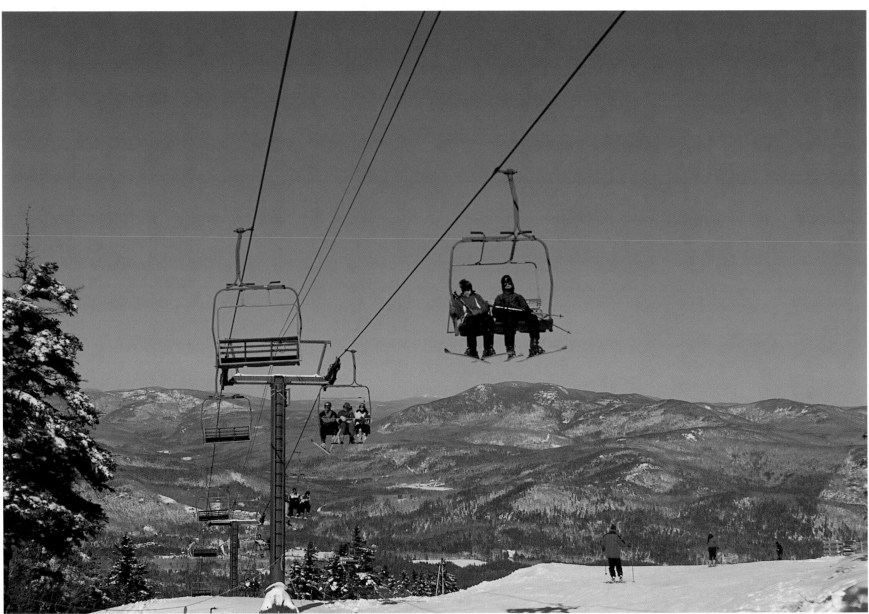

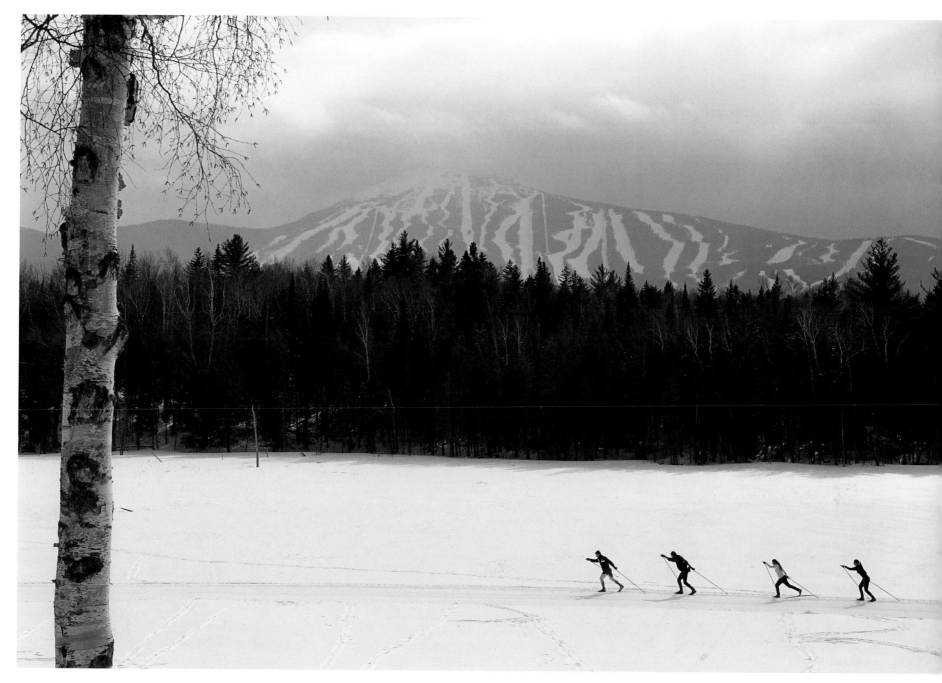

Sugarloaf USA, accessed through Kingfield and
Carrabassett Valley, has excellent downhill facili-
ties including Maine's only snowfields, as well as
a state-of-the-art Nordic skiing center. Here,
four members of the Mount Abram High School
ski team practice on the resort's groomed cross-
country trails.

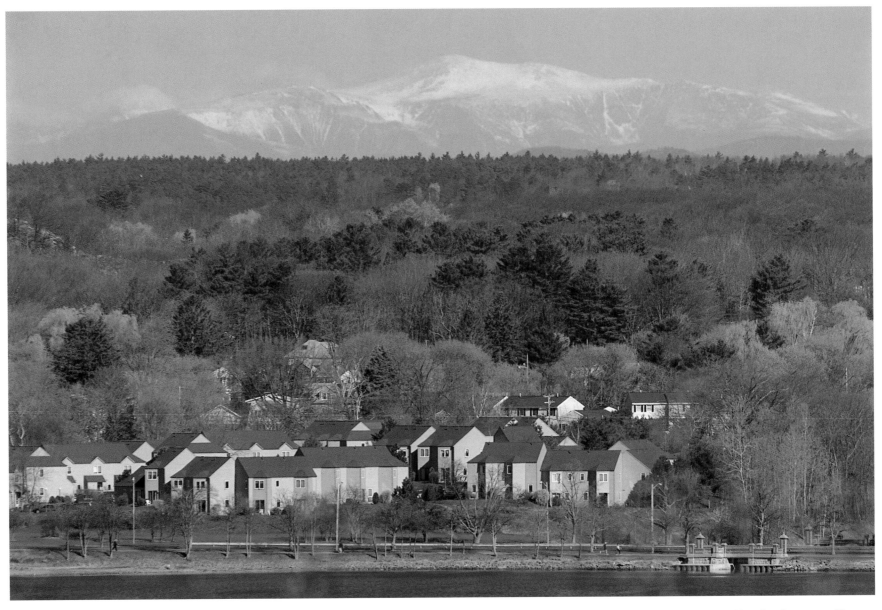

As spring approaches in Portland, snow still covers Mount Washington, the highest peak in New Hampshire's Presidential Range, some one hundred miles from this viewpoint on Munjoy Hill. In the near distance, joggers exercise on the trail that encircles Broad Cove as forsythia begins to bloom around neighboring condominiums.